MW00335359

TH BEIRUT CALL

Harnessing creativity for change

THE BEIRUT CALL

Harnessing creativity for change

Edited by **Pamela Chrabieh & Roula Salibi**

Published by **Dar al-Kalima University College of Arts and Culture**
Produced by **Elyssar Press**

Published by Dar al-Kalima University College of Arts and Culture © DAK 2021
Bethlehem, Palestine

Produced by Elyssar Press
Redlands, CA
USA

First Printing, 2021

ISBN 978-1-7334529-7-7

Book design and production by Stephanie Aoun Bou Karam @5dstudios
Compiled and edited by Pamela Chrabieh and Roula Salibi
Cover photo by Nada Raphael "Scream"

Library of Congress Cataloging-in-Publication Data in progress

" لبيروت
من قلبي سلامٌ لبيروت
و قُبلٌ للبحر و البيوت
لصخرةٍ كأنها وجه بحارٍ قديمِ "

" To Beirut
I send a greeting from my heart to Beirut,
I send kisses to the sea and to the houses,
to a rock that looks like an old sailor's face. "

Excerpt of Fairuz's song, *Li Beirut*

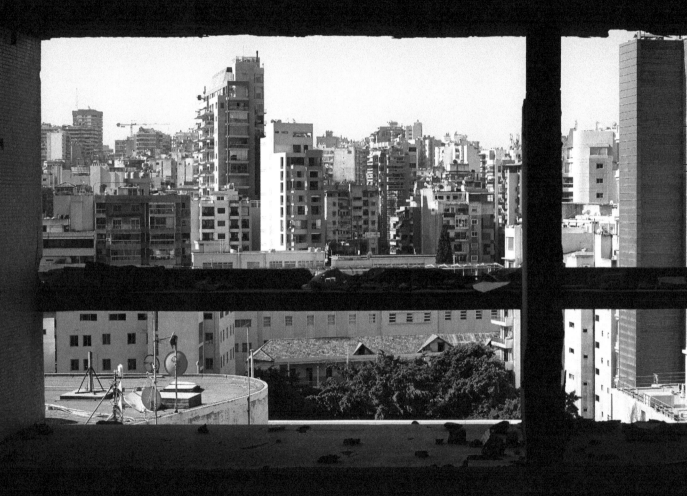

1975: A view of Beirut from one of the many Holiday Inn hotels opening along its facades. This establishment was notorious during the War of the Hotels in the 1975 Lebanese Civil War for experiencing some of the most atrocious acts of that period.

TABLE OF CONTENT

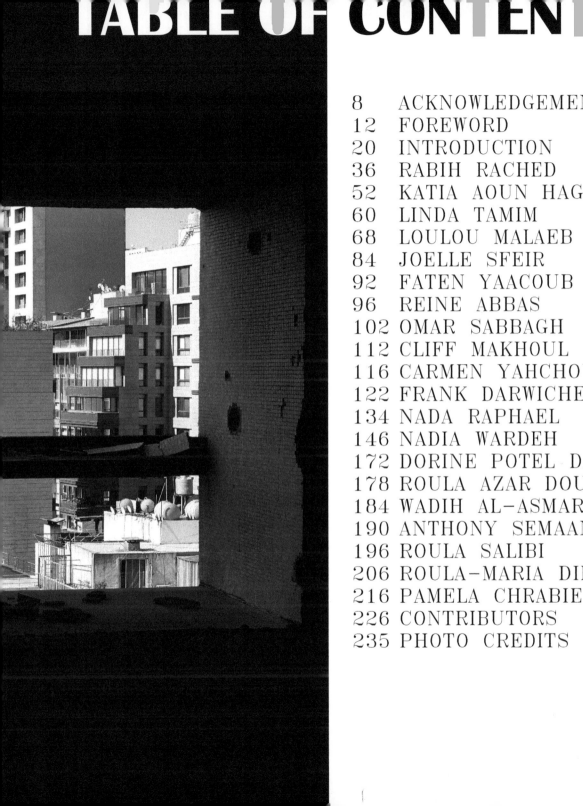

ACKNOWLEDGEMENTS

Thanks are due to all who contributed to the Beirut Call. It was a cooperative effort between the editors Dr. Pamela Chrabieh (Nabad Program Manager - nabad.art) and Ms. Roula Salibi (Nabad Project Coordinator), Dar al Kalima University College of Arts and Culture with its president Reverend Dr. Mitri Raheb, Elyssar Press with its founder Ms. Katia Aoun Hage, Nabad's donors, Nabad's partners in 2020-2021 (SPRKL, Meadows NGO, Plan Bey, Haven for Artists, Beirut Jam Sessions), and countless authors, artists and activists.

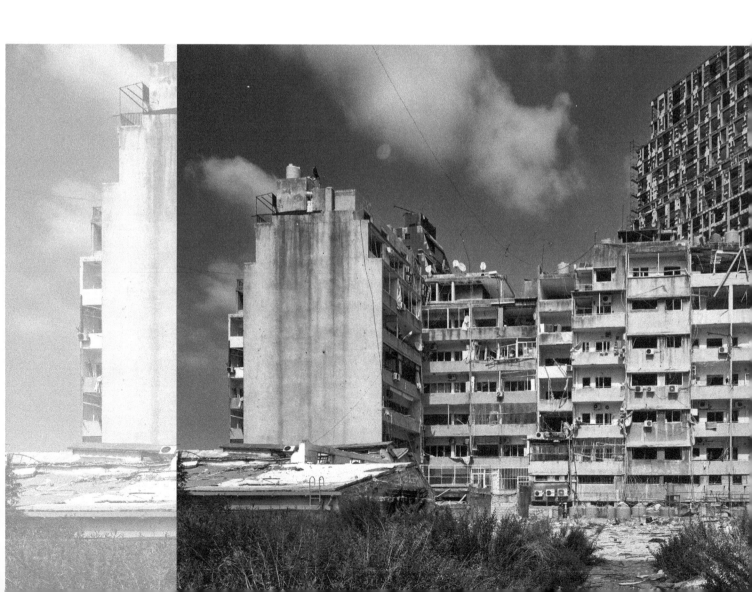

A special thank you is extended to the 21 contributors to this anthology:
Anthony Semaan, Carmen Yahchouchi, Cliff Makhoul, Dorine Potel Darwiche, Faten Yaacoub, Frank Darwiche, Joelle Sfeir, Katia Aoun Hage, Linda Tamim, Loulou Malaeb, Mitri Raheb, Nada Raphael, Nadia Wardeh, Omar Sabbagh, Pamela Chrabieh, Rabih Rached, Reine Abbas, Roula Douglas, Roula-Maria Dib, Roula Salibi, Wadih al-Asmar.

Thanking also the 61 Nabad's Arleb (arleb.org) selected artists for the success of the first online exhibition that took place between February and April 2021:

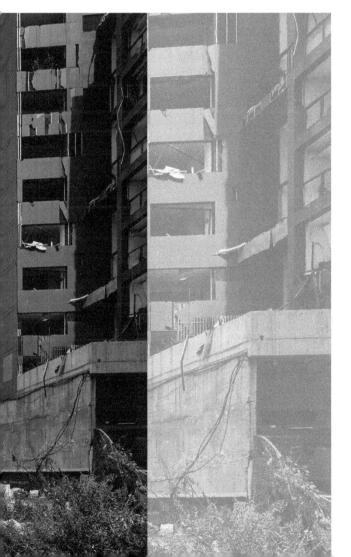

Tamara Haddad, Khoder El Hajj Hassan, Carmen Yahchouchi, Betty Khatchikian, Chloe Sleilati, Maral Maniss, Diane Audi, Gilbert Loutfi, George Khoury (Phat2), NAjwa Nahas, Celine Alam, Ingrid El Naccour, Laurie Mikaelian, Hiba Hteit, Olga Safa, Toufic Melhem, Michel Raad, Yasmine Mehio, Manar Ali Hassan, Sylvana Eid, Zahraa Hayat, Chris Assoury, Maroun El Asmar, Elio Zeaiter, Amir Shaaban, Stephanie Cachard, Sahar Chehab, Neam Kassem, Rasha Hajjar, Ragheb Barake, Ahmad Jouni, Merheb Merheb, Lea Morcos, Aya Catherina Elias, Lea Skaff, Mona Jabbour, Paulette Touma Eid, Samia Soubra, Joyce Hatem and Dina Ariss, Nadine Mneimneh, Stephanie Sotiry (Madame Cefanie), Dana Hassan, Christina Batrouni, Monica Moughabghab, Faten Khalil, Nour Tamim, Charbel Torbey, Ayda Makhoul, Tamara Nasr, Nayla Feghali, Jamal Maalouf, Wafa' Khoury, Nada Raphael, Racha Mourtada, Elise El Rassi, Tala Awadi, Zarifi Haidar, Amira Al Zein, Celine Khairallah, Rania Naccour, Peter Abdel Karim.

Aftermath 1: A few buildings behind the Electricité du Liban offices near the Port of Beirut that were affected heavily by the blast. We can clearly see the desolation of the buildings' facades.

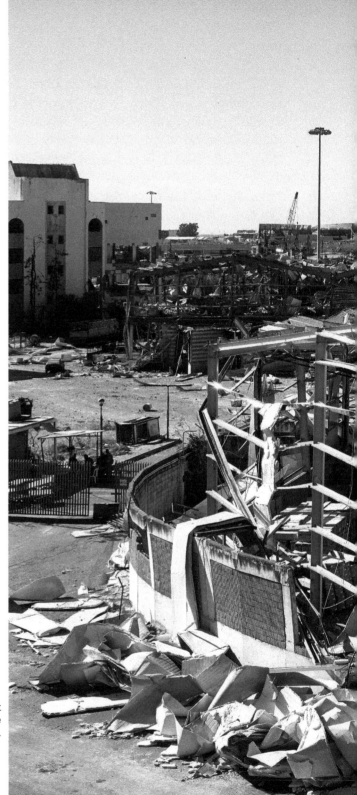

Aftermath 2: A section of Beirut's port on August 5, 2020, torn apart by the blast that took place a day before. It killed more than 200 people, while leaving more than 6000 injured and almost 300,000 homeless and displaced.

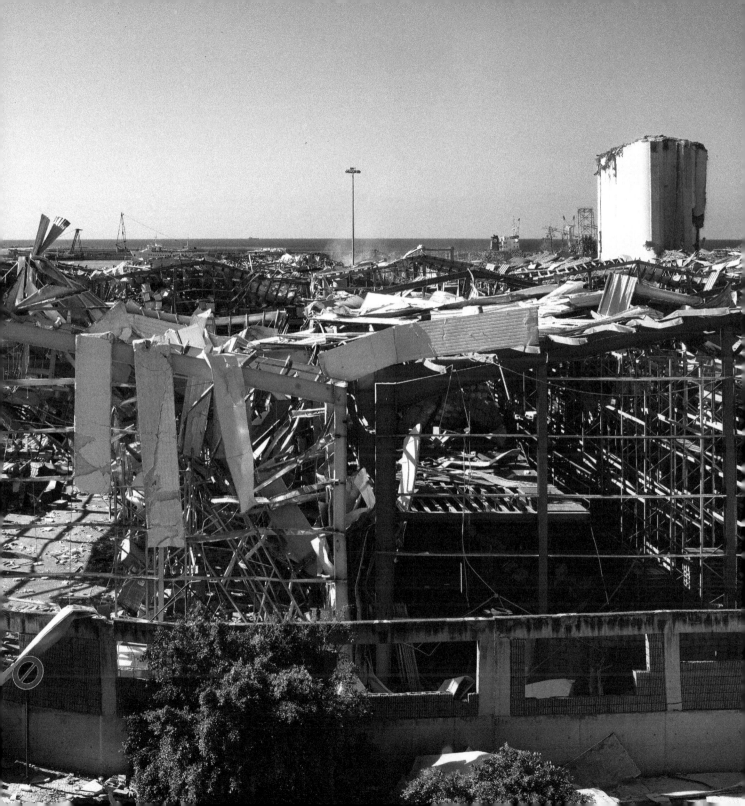

FOREWORD

Nabad: The Art of Breathing

The explosion at the port of Beirut on August 4, 2020, was a catastrophe of unimaginable magnitude. It left hundreds of people dead, thousands injured, and many more thousands homeless. The images transmitted on social media and on TV screens reminded me of images from Hiroshima and Nagasaki. For me, in Bethlehem, Palestine, I felt we had to do something. Staying a spectator was not an option. But what could we do when we were far away? What could we do with limited resources? How could we show our friends in Beirut that we cared? Statements of support, litanies and prayers would not be enough. We learned that lesson as Palestinians—words are not enough. It was imperative for us that we needed to walk the talk, to provide something tangible, something concrete that makes a difference. As Dar al-Kalima University, the first and only University in Palestine with a focus on art and culture, it was clear that the best intervention must be in the field of arts and culture. This made sense since many of Beirut's art galleries, museums, and ateliers had been damaged, and artists had been put out of work.

In the context of war, devastation and unrest, art is not usually seen as a necessity. Often, I meet people and donors who think that art in such a context is a pure luxury that we cannot and should not afford. For such donors, humanitarian aid is primary. People are in dire need of bread to eat, to fill their stomachs so that they can think. That is the usual argument. Our tragedy as Palestinians has been that our struggle, ever since the Balfour Declaration, has often been portrayed as a humanitarian crisis rather than one related to identity and self-determination. Jesus reminded us that people "shall not live by bread alone". Art is one of the most important elements for people's survival. When people are under immense constraints and when everything around them is falling apart, culture is the art of breathing. In conflicts, people focus on those who kill "the body" but often forget about those who kill "the soul", that is, the dignity, creativity, and vision of a people. Without a vision, nations "cast off restraints". Art allows the soul not only to

survive but to thrive. Culture is the art of refusing to be only on the receiving end, of resisting being perceived as a mere victim. It is the art of becoming an actor rather than a spectator. It is the art of celebrating life in the midst of death and hopelessness, the art of resisting creatively and nonviolently.

Art at times of devastation is an important tool with a therapeutic edge. Explosions, invasions and war leave people traumatized, speechless, perplexed, and disturbed. Unfortunately, both the Palestinians and the Lebanese know that reality too well. While our societies do not have enough mental health counselors to deal with all the trauma, artists often step in to provide therapy, relief, and comfort. They provide the space needed to recover. Not only is art crucial in times of despair in order to resist hopelessness, it also allows genuine self-expression and authentic communication of one's story. Art is the way we determine who we are—as defined by ourselves and not by others. Art is the medium through which we communicate what we really want in a language that differs from that of political semantics and religious formulas. Within the Levant, people have reached a stage where they feel that political rhetoric no longer represents their thoughts and needs. They are also feeling suffocated by certain forms of religious expressions that contain too much religion and too little spirituality. Art provides a sacred space where people learn how to breathe freely in times where fresh air seems to be in short supply. That is why I believe that art is one of the most important pillars in any society. Its role in our region will determine for many people whether the Levant is their homeland, not only by birth, but more importantly by choice. Hopefully, what happens in the cultural zone will impact the direction in which our countries are heading: towards an open society with guaranteed freedom of expression; towards a state that allocates resources to ensure that the cradle of the three monotheistic religions will be a major cultural hub for humanity.

Finally, art is an important bridge between our societies and the rest of the world. Although art relates to self-expression, it is always conducted in relation to others. Encountering the other is always important for understanding oneself. It is in the

light of facing a different context that one realizes one's own unique heritage. Thus, art becomes the space where people can meet others and themselves, where they can discover a language that is local and yet universal, and where they can realize that to breathe, one must keep the windows wide open for new winds brought across the oceans and seas. Art is the means that empowers us to give a face to our people, to write melodies for our narrative, and to develop an identity that is deeply rooted in our soil like an olive tree or a cedar, yet whose branches reach high into the open skies. Our hope is that this publication will contribute to this purpose.

It is for these reasons that we, at Dar al-Kalima University, decided to respond to the August explosion with an artistic intervention. Through art therapy workshops, artistic performances, and digital platforms and publications, we seek to strengthen the civil society, cultivate talent, and communicate hope so that a renewed spirit will continue to blow within, throughout and across Beirut. We will cast away all clouds of hopelessness and corruption, believing that our people deserve to "have life and have it abundantly". We are honoured at Dar al-Kalima University in Bethlehem to offer this very modest sign of friendship to the people of Beirut and Lebanon at large. This would not have been possible without the tireless work of my colleagues, Dr. Pamela Chrabieh and Ms. Roula Salibi. My sincere thanks goes to them, to our partners in Meadows, Beirut Jam Sessions, Plan Bey, Haven for Artists, to the many artists that have contributed to the success of this project, to Elyssar Press, and last but not least, to SPRKL for being such a reliable partner.

Rev. Dr. Mitri Raheb
President
Dar al-Kalima University
Bethlehem, Palestine

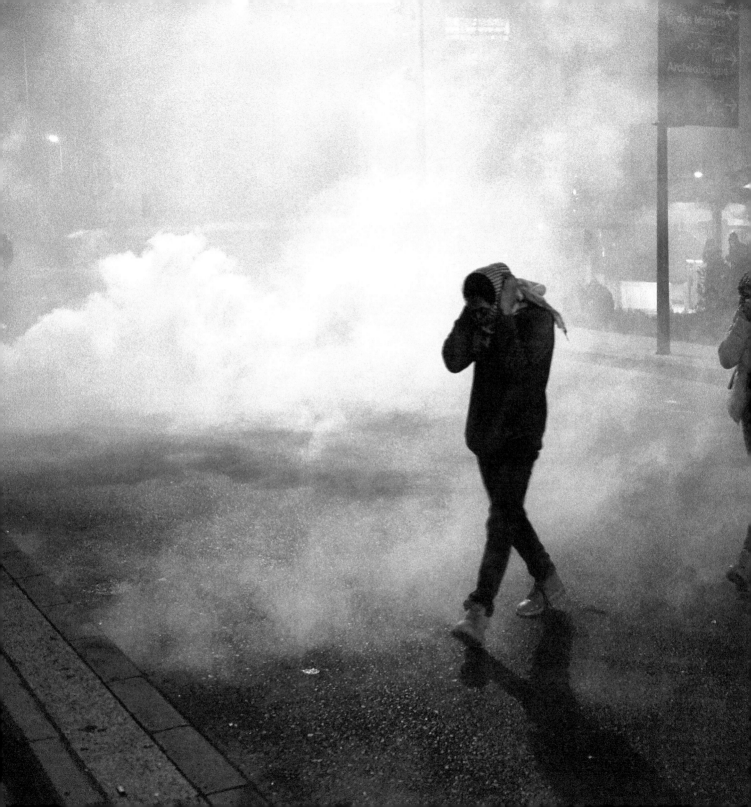

WEYGAND

Weygand Road: Protesters leaving the warlike zone on Weygand Street in downtown Beirut, January 18, 2020, as anti-riot police and the army fired tear gas bombs to scatter all demonstrators who tried to enter the parliament by force.

"[Beirut has gathered]

the manners and customs,
the flaws and vengeance,
the guilt and debauchery of

the whole world into her belly."

Etel Adnan, *Sitt Marie Rose*

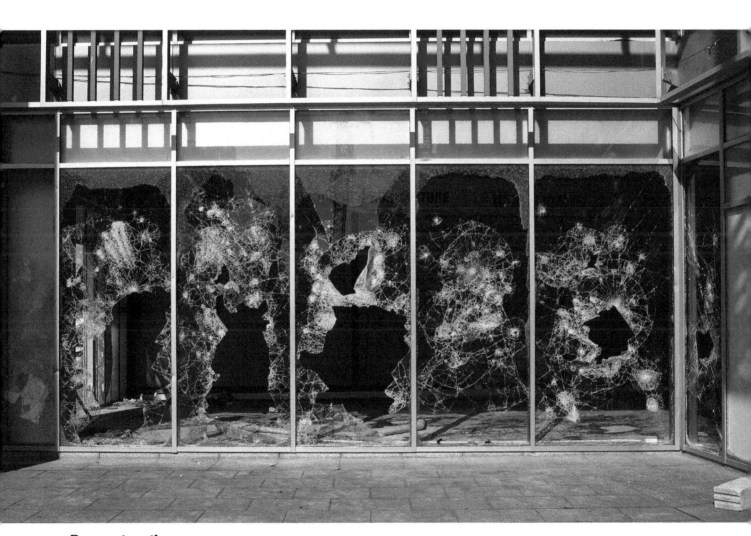

Deconstruction: A view of one of Beirut's downtown buildings assaulted by protesters during the first hours of the uprising of October 17.

INTRODUCTION

Out of the Margins:

Towards the Rise of Beirut's Arts and Culture Scene?

"The feeling of being on the edge of something could be the signature of the complicated times we inhabit. Fringes of experiences, speculations, memories and histories—call it by any other name; limits, edges, borders, frontiers or margins of all kinds—are thresholds waiting to be crossed, spaces rife with the seductive aura of transgression. As the twilight which invades both night and day, margins infiltrate the centre and the core expands to the periphery" (Thomas 2012, 155-168).[1]

The 4th of August 2020 port of Beirut explosions left more than 200 dead, over 7,000 injured, 300,000 homeless, and countless traumatized individuals and communities. At that time, my daughter Jana and I were at home, almost 12 kilometers away, and my husband Nemr was at his office, less than 8 kilometers away. We first thought there was a violent earthquake. My daughter was shouting, and I tried to comfort her while keeping her far from the windows—call it 'survival instinct'. Seconds passed by, then hell unleashed its fury…

I had never experienced such a blast magnitude, although I was born and raised in the 1970s-1980s war in Lebanon. Like so many other citizens, my parents, my sister, and my extended family and I had already endured so much; we have survived bombshells and snipers, as well as a scarcity of electricity and water, and a lack of consistent, safe shelter. We have survived escape journeys, ghettos, destruction, death, despair, and exile… but nothing prepared us for this cataclysm, one of the most powerful non-nuclear blasts in the history of mankind!

1 Tom Thomas, "Edward Said and the Margins," Text Matters, Vol. 2, No. 2 (2012): 155-168.

Beyond destroyed buildings, infrastructure, and heritage, this apocalypse, this crime against humanity, added even more scars and traumas to the filled jar that every Lebanese has to carry, whether in Lebanon or abroad. It tore apart families and loved ones, it stopped beautiful hearts from beating, and it wrecked an already fragile local arts and culture scene due to the ongoing socio-economic and political crisis, and the Covid-19 pandemic.

Indeed, major art galleries and museums were either partly damaged or completely destroyed, along with countless smaller art studios and creative enterprises like Gemmayzeh and Mar Mikhael. These neighborhoods were home to cafes, restaurants, and galleries, as well as venues for concerts and poetry slams, furniture shops, jewelry shops, and designer clothing shops. These neighborhoods were called by many "the beating heart of Beirut's cultural life", but following the blasts, will they be able to bounce back after all the hardship?

It is true that several foreign governments, international organizations, and local NGOs have been facilitating relief efforts since the first two weeks of August 2020, and funds have been made available for museums and cultural initiatives such as the Arab Image Foundation, the Art Relief of Beirut, Books for Beirut, Fund for Studio Safar, Mophradat, and Lebanon Solidarity Fund by AFAC. However, most efforts were concentrated on immediate relief and reconstruction. In addition, these efforts focused on big players in the arts and culture scene such as the National Museum which received help from the Louvre Museum; several established local and international artists also auctioned their artworks to help people in need.

The local arts and culture scene will need long-term support at all levels, with a particular focus on the margins, the small creative enterprises, art NGOs, as well as support for emerging and marginalized artists, as they play an important role in supporting their local communities—they are these communities' pulse points, from providing a hometown feel for localities, to sparking healthy competition with larger competitors and encouraging innovation and creativity by adding unique spins on the

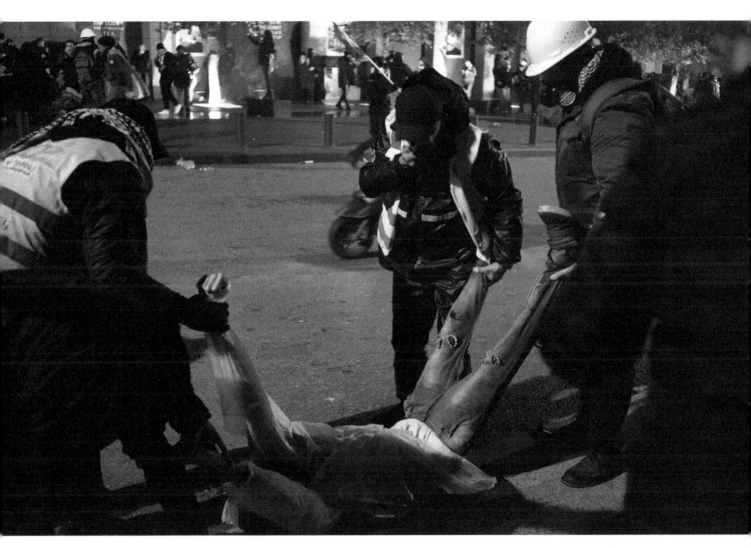

The Wounded: An unconscious protester being carried away to safety by fellow demonstrators on January 18, 2020, in Beirut. The army and anti-riot police bombarded civilians with tear gas and water to scatter everyone who tried to enter the parliament by force.

artworks and activities they offer. These artists and collectivities help raise awareness about urgent socio-economic, political and environmental issues. They heal wounds, create and sustain jobs, and keep urban areas vibrant and buzzing with shoppers and tourists; their venues—whether physical or virtual—are places in which people gather, curiosity is piqued, world views are expressed and challenged, and critical thinking and compassion are expanded.

For this reason, the Nabad program (nabad.art)[2] was established by Dar al-Kalima University College of Arts and Culture, largely as a response to the August 4th Beirut port blasts. This program empowers artists, art organizations, and creative enterprises in Southwestern Asia and North Africa to implement their artistic and cultural ideas, and market their artworks. It offers both short and long-term support, and its work is based on four main pillars: art intervention, outreach, empowerment, and content production. Nabad means heartbeat in Arabic, as the program strives to become a heartbeat embedded with the larger beating heart of local and regional arts and culture, a vital impulse of hope amid war, amid destruction and amid instability. Nabad is a driving pulsation towards social and community transformation.

A first example of Nabad's funded projects in 2020-2021 is Plan Bey. Founded in 2010 by Karma Tohmé (artistic direction, graphic design, and production) and Tony Sfeir (editorial direction, exhibition, and retail) and based in Beirut, Plan Bey is an artisan-publisher of artists' multiples, books, and prints. It consists of a design and production workshop as well as two exhibition and retail spaces that feature Plan Bey's editions and publications developed in its workshop in direct collaboration with Beirut-based artists. This creative enterprise's premises and equipment in Mar Mikhael were damaged by the Beirut port blasts, but it never stopped its wonderful work of producing and preserving local cultural memory. One of Plan Bey's book projects following the blasts and partly funded by Nabad is entitled "Beirut Urban Ruins / Save it on Paper by Maha Nasrallah", featuring work by an artist who has been making watercolor sketches of abandoned houses since 2016.

2 "Home," Nabad program, Accessed February 21, 2021, http://nabad.art/

As Karma Tohmé states: "Following the urban sketching global movement, which stipulates the sketches are made live and in-situ, she [Maha Nasrallah] concentrates on houses that are usually invisible to the passerby, singling them out from their surroundings and bringing them to the light as remainder and reminder of the old urban fabric of Beirut".

In 2016, Plan Bey published a selection of Nasrallah's drawings covering the districts of Clemenceau, Hamra, Rass Beirut, and Manara, as prints, posters, and a limited edition book-object that comes in the shape of a folded leporello. However, Plan Bey wanted to make a more comprehensive and systematic publication featuring all the drawings produced by Nasrallah with a mapping of their whereabouts and relevant texts giving some context to the project and information related to the preservation of the heritage buildings of Beirut. According to Tohmé: "The Beirut port explosions have brought the subject back, and made it ever more relevant and urgent, especially since Maha Nasrallah has drawings of the directly affected areas (Gemmayzeh, Mar Mikhael) that are not yet published. These traditional often abandoned houses are an important and integral part of the identity of Beirut and were some of the most affected buildings by the August 4 explosions. Their rehabilitation and the preservation of their memory, at least 'on paper' is essential to the collective perception of Beirut".

A second example of Nabad's funded projects is MEADOWS. The Nabad program helped fund this organization's art therapy workshops for nurses at Saint George Hospital University Medical Center in Beirut—nurses who were heavily traumatized by the Beirut port blasts—and fund their art therapy training workshops for activists and social workers. MEADOWS—Mediterranean Endeavors Advancing Of Widespread Sustainability—is an NGO that was officially established in 2007 in Beirut with the purpose of promoting development of sustainable nature by means of social and cultural activities, as well as raise public awareness through lectures, exhibitions, workshops, and training sessions. Since 2006, MEADOWS has been organizing art therapy workshops for children and adults affected by wars and crises, and training sessions with social workers

and young activists in Greece, Jordan, and Lebanon. Art therapy and training workshops make use of several artistic practices such as drawing and sketching, along with playful exercises and theater techniques, while also creating safe spaces for storytelling and dialogue. Art therapy has been used for decades to help people who experience PTSD (post-traumatic syndrome disorder). There is a great deal of work and research pioneered in the UK and the USA, and art therapy has been widely researched among abuse and disaster survivor populations. The work done by MEADOWS through art is ongoing and vital to help people process the traumatic cataclysm of the 4th of August. Following the blast, MEADOWS provided and still provides an outlet when words failed . Similarly to what the main literature on art therapy highlights, the practice of art therapy by MEADOWS revealed the following significant outcomes: 1) the ability of traumatized individuals to express thoughts which cannot be verbalised, 2) the improvement of social relationships, and 3) notable improvements in experiencing less anxiety. Through discussion with MEADOWS' co-founders Lena Kelekian and Hagop Sulahian, as well as through personal observation of the Saint George Hospital University Medical Center visual art productions and nurses' verbal reflections on their experiences in art therapy, one can only conclude that participation in a long-term, stage-based, structured art therapy program (through both group and individual sessions), can enable traumatized individuals to identify and articulate the complexity of their lingering trauma symptoms, thus fostering improvement in their communication with their loved ones. In turn, this leads to improvements in their overall quality of life.

A third example of the work Nabad enables can be seen by the Haven For Artists (HFA) NGO, which is an all-inclusive arts organization founded in 2011 and based in Beirut. HFA works at the intersection of art and activism, combining creative and humanitarian methods to facilitate a safe space for the exchange of information, tools, and skills in order to create a better society. The HFA team believes that art is uniquely able to explain complex issues in an accessible way to a diverse audience in a non-confrontational manner. To this end, it connects talented arts from the Middle East with advocacy groups, activists, and NGOs striving to further human rights, particularly concerning LGBTQIA+

persons and women. HFA hosts and produces regular visual exhibitions, festivals, concerts and artistic gatherings, roundtables, workshops, creative forums, and artistic aspects of humanitarian campaigns and events. As one of Nabad's partners in 2020-2021, HFA organized a street exhibition and campaign entitled "Beirut is its People" in March 2021, featuring large paper prints of seven elderly resilient women who refused to let go of their houses as they watched young activists and artists from their balcony walking by, following the Beirut port blasts on August 4th, 2020. HFA wanted young people to remember the smiles and hellos, to lessen the tension of the rubble and of destroyed facades, to derail the focus from the heavily impacted areas of Gemmayzeh and Mar Mikhael by the blasts that became its daily reality, to reinstall a certain sense of pride and identity, to reclaim the public heritage space, and to add a new layer of feminist resilience to local resilience arts, etc., by portraying members of society who are essential for the cultural definition of these streets. As HFA founder Dayna Ash stated, "We would like to honor them, while using the many talents of this same youth, by imprinting the walls with their faces that have and still are, writing history on their own terms, by simply existing and maintaining their physical position, regardless of the challenges that can come with age, a financial crisis, a pandemic, and one of the biggest non-nuclear blasts history has witnessed".

A fourth example of Nabad's funded projects is the Beirut Jam Sessions (BJS). Founded in June of 2012, BJS is a music organization that promotes concerts in Lebanon and the Middle East by organizing shows for international, regional, and local acts. In addition, it films concerts on its popular Youtube channel titled Beirut Jam Sessions, often having the international and local acts perform together (or solo) in an unplugged, natural setting in Beirut.[3] This channel was and still is the first of its kind in the Middle East. It provides focused exposure for emerging and established talents. BJS' mission is to bring live music back to Beirut and to put this wounded city on the cultural world map again, especially following the August 4 port blasts, the socio-economic crisis, and the pandemic impact on local arts and culture. As one of Nabad's partners in 2020-2021, BJS put together a series of live and virtual concerts called 'Tiny Gigs'.

3 For Beirut Jam Sessions, please explore https://www.youtube.com/user/beirutjamsessions.

The live concerts gathered an audience of 10 to 30 people each, with social distancing rules applied, in various cultural locations in Beirut such as Arthaus, MIM Museum, Feel 22, and Union Marks. All gigs were totally unplugged, raw and filmed in BJS usual session format, and videos were released on Youtube. According to BJS founder Anthony Semaan, "we adapted to the situation and rules while maintaining a clear objective: gradually bring back live music to the city and offer both financial and promotional support to the artists". BJS' Tiny Gigs are what we can call "artistic solutions" to the predicament of Lebanon and the Levant region, crossing over barriers with experiences that individuals and communities can witness, and metaphors for humanistic emancipation as they are able to relate divergent musical and cultural backgrounds. Tiny Gigs are the product of polyphony in music, which allows no domination of one voice over others, and helps preserve difference while opening the door to dissidence and alternative views and sounds.

A fifth example of Nabad's development is through the international Beirut-based integrated marketing company SPRKL, with the help of multiple local talents and experts of a not-for-profit digital platform, Arleb (arleb.org). Arleb is dedicated to artists and creative enterprises in Lebanon and was launched in February 2021 as one of Nabad's program 2020-2021 projects. It aims to empower local artists by offering them an opportunity to showcase and sell their artworks to new audiences on an international level. It also seeks to raise awareness about resilience & resistance arts and culture produced by emerging and marginalized artists. Arleb is an inclusive space as it encompasses both established and emerging artists' profiles, along with different socio-economic backgrounds, cultural/religious/gender identities, generations, and narratives. We all need to be mirrored in the public sphere to be considered fully human, fully social beings, and because marginalized populations have fewer role models in society, Arleb seeks to create possibilities for individuals and communities to tell their stories from and out of the margins.

These examples of post-August 4th projects and initiatives are essential, and they are only a start. More action, innovation and investment are needed to revitalize local arts

and culture communities. Lebanon is in great need of viable methods of growth from the tragedies of wars, explosions, and multiform crises, and the arts and cultural scene provide democratized ways of establishing inclusive cultural identities. This wounded country, and particularly its capital Beirut, need their arts and culture to thrive in order to create a foundation of national understanding, across borders, sectarian belongings, and generations; the arts communicate snapshots of times that can be preserved and interpreted long after the events have passed and languages have been forgotten. It is obvious that Lebanon's past is filled with examples of artists, poets, and authors' predilection for resilience and resistance arts, but since October 2019, we have also been witnessing—and even more since August 4th, 2020—a myriad of arts and culture expressions and acts channeling self-identity, unity in diversity, and dissidence against oppression, social inclusion, and war memory. This is worth recognizing, empowering and communicating.

It is more than urgent to support talented artists, arts NGOs, and creative enterprises that operate in the margins and provide access to opportunities that the Lebanese state is not bringing forth. These artists and organizations can provide a critical lens that educates, provokes, and holds a mirror to the Lebanese society, thus influencing what gets attention in the public sphere and shaping perspective and opinion. They can demonstrate their potency to address social goals of healthy communities and inclusive societies. They can also help to create collective identities and promote stewardship among residents and stakeholders, and thus can be especially significant in low and moderate-income communities that are striving to improve the quality of life and opportunities for residents.

While keeping in mind and working on this much needed support, there are several issues to address, and challenges to face. These include the general lack of understanding of the arts and culture as a change strategy; there is a continuous struggle to acknowledge how arts and culture integrate with society's social change efforts. Also, there is the lack of evidence of the value or impact of the arts as a strategy for achieving social and civic goals. With the absence of state funding and support,

there is also the risk of dependence vis-à-vis international organizations' agendas and the disintegration of the local market along with the reduced purchasing power of locals.

There are of course other issues and challenges, but the main question remains: why would we, as activists, authors, poets, artists, organizations, and as citizens who are concerned with rebuilding our society, focus on the arts and culture while the poverty rate will soon reach 75% of the population? Is it ethical? Why would we care about our local arts and culture? Why would we use art strategies, tools, media, and techniques in our overall activism strategy, and implement projects of society transformation through the arts? As Joey Ayoub explains it in his newsletter Hummus for Thought: "Today, we live in a state of profound cynicism where no individual action is believed to be capable of leading to genuine change. At the same time, we live in a country of talent and extraordinary resilience. The challenge, therefore, is to break down the imaginary barrier which separates the imagination from the cold reality of everyday life. This is not only feasible, but a moral imperative". And as an artivist—artist and activist—for more than 25 years, I would simply say that beyond a moral imperative, it is a humane one. We all have the responsibility to create a more humane society, and the arts and culture can help us in this endeavor. They are affective and effective tools with which to engage communities in various levels of change. They provide a voice to the voiceless. They help heal wounds. They help connect people beyond differences. They help people unleash their imagination, have a vision, and have hope for the future. And when their creative power is combined with the strategic planning of activism, then long-term social and political change can be brought about.

What about the ethical aspect of supporting arts and culture in a devastated country? Because they can help keep the focus on marginalized communities and provide multiple services and opportunities in terms of gainful employment via an equitable share of profits from artists' sold work. They can also offer accessible spaces of expression, be a platform for agency to effect change, and provide visibility to issues of poverty, discrimination, injustice, and marginalization.

"Arts and culture are essential for building community, supporting development, nurturing health and well-being, and contributing to economic opportunity. Collectively, arts and culture enable understanding of the past and envisioning of a shared, more equitable future. In disinvested communities, arts and culture act as tools for community development, shaping infrastructure, transportation, access to healthy food, and other core amenities. In low income communities, arts and culture contribute to strengthening cultural identity, healing trauma, and fostering shared vision for community" (Rose, Daniel, and Liu 2017, 12).[4]

At first, the worlds of arts and culture on one hand, and of activism on the other, can seem at odds with one another. Activism moves the material world, while arts and culture move the heart, body, and soul. But they are complementary: social and political change do not just happen. They happen because people decide to make change, and because they were moved by affective experiences with physical and virtual actions that result in concrete effects. We are moved to be engaged through stories, symbols, experiential activities, and popular culture... And artistic activism is a much-needed combination between the arts & culture and activism, and it can take place at home, in public spaces, and on social media. Artistic activism is much more attractive, approachable, and friendly than traditional art or activist practices. It also has a positive ability to surprise us when expectations are negative. It disrupts people's preconceived notions of arts, activism, politics, resistance, resilience, justice, war, peace, etc. It helps us deconstruct stereotypes and bypass fixed ideas and ideologies by cross-ing boundaries. It remaps cognitive patterns, offers alternative ways of protesting to the traditional forms like marches and demonstrations, and sustains lasting changes because it targets change in values, beliefs, and patterns of behaviors... It targets mentalities, and that is cultural change.

4 Kalima Rose, Milly Hawk Daniel, and Jeremy Liu, "Creating Change through Arts, Culture, and Equitable Development: A Policy and Practice Primer," Policy Link (2017), https://www.policylink.org/sites/default/files/summary_arts_culture_equitable-dev.pdf.

Many have proved it: culture lays the foundation for politics. Cultural shifts, especially non-violent shifts and therefore socio-political shifts, do not only need to be big for changes to happen; they can be a cumul of small shifts. And these shifts ought to, as the Dalai Lama declared, "awake people to compassion" at the same time as motivate them to revolution, or at least to critique and to continuous cultural resistance. Arts and culture must become "imminently critical", in the same manner that Adorno and his Frankfurt School colleagues imagined philosophy should behave, if it is to enable greater human freedom. But it can't stop with merely critiquing; it has, as Marc Levine would argue, "to take the next step and promote a vision, a path and a method to create a new kind of accord between the people who must act in concert if the system is to be seriously challenged".[5] This vision/path/method should be inclusive, especially since most established cultural institutions in Lebanon, both public and private, are embedded in a politics of inequality that silences dissident voices and practices.

The Beirut Call contributors remind us that humanity is formed in and by the complexities of overlapping territories and intertwined histories. They remind us of the benefits flowing from arts and culture, as these help shape reflective individuals; facilitate greater understanding; increase empathy and respect; promote not only civic behaviours such as voting and volunteering, but also viable alternatives to current assumptions; help fuel a broader political imagination; help minority groups to find a voice and express their identity; and help peacebuilding and healing by assisting communities to deal with the sources of trauma and bring about reconciliation.

All contributions to The Beirut Call inspire us to think about the impacts of arts and culture on cities and urban life, urban regeneration, modes of engagement with cultural activities, tasks that are neither all metropolitan nor all peripheral, and acts in the spirit of initiating dialogue across asymmetrical divides and of peripheralizing centers... They inspire us to deconstruct the internalized status quo and articulate coalitions between differences. They inspire our souls to re-emerge, or as Lebanese-American philosophical essayist, novelist, poet and artist Gibran Khalil Gibran once wrote: "Out of suffering have emerged the strongest souls; the most massive characters are seared with scars".

by Dr. Pamela Chrabieh

5 Mark Levine, "When Art Is the Weapon: Culture and Resistance Confronting Violence in the Post-Uprisings Arab World," Religions, 6 (4) (2015): 1277 - 1313.

Vernacular: A typical Lebanese house withered by time in the Beirut area of Gemmayze.

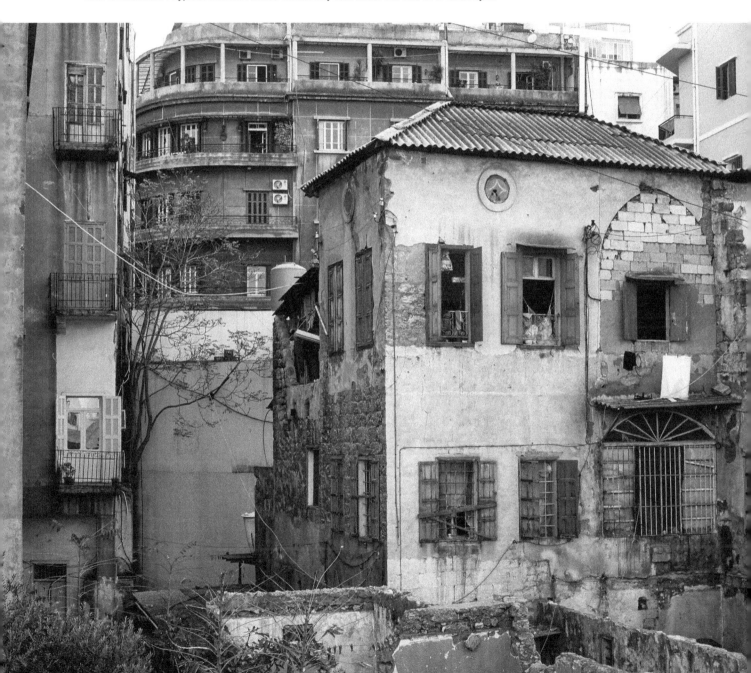

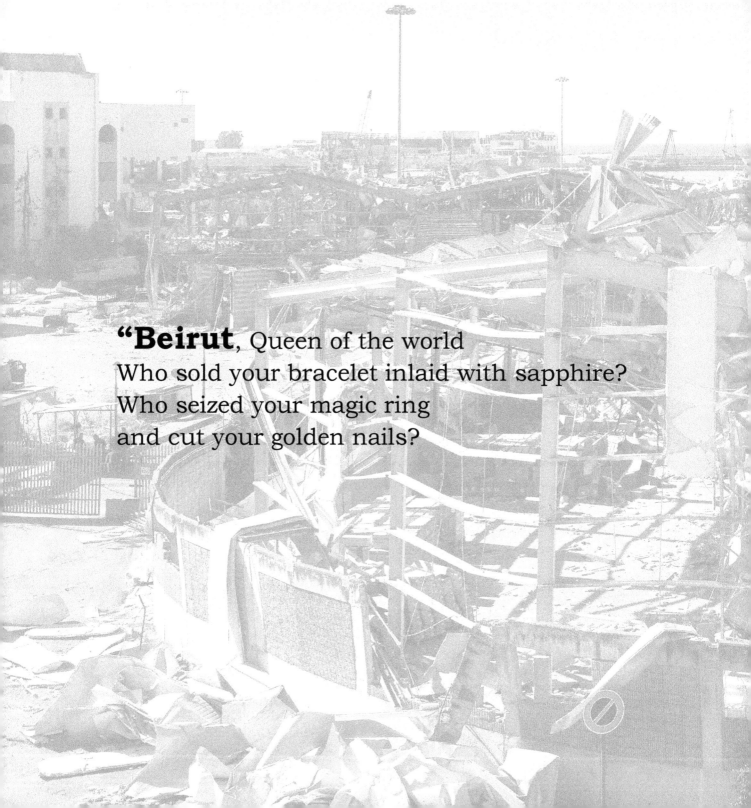

"**Beirut**, Queen of the world
Who sold your bracelet inlaid with sapphire?
Who seized your magic ring
and cut your golden nails?

Arise, Beirut,
so that the world may survive...
that we may survive...
that love may **survive."**

Nizar Qabbani, *Beirut! O Queen Of The World*

RABIH RACHID

Glances at the History of Culture in Beirut

Rabih Rached is a 43 year-old Lebanese agricultural engineer from Marjeyoun (South Lebanon); but he fell in love with history during his school years in Jamhour, located on a beautiful green hill east of Beirut. Reading about history became his favorite hobby that he used to enjoy after work and in his spare time. In fact, as a child of a war, the so-called Lebanese Civil War that encountered a lot of external interventions, he always wanted to understand "why we got here". He lived twice abroad—in France and in the United Arab Emirates. In both countries, he met people from all over the world with diverse cultural backgrounds and religions, and made solid friendships with a lot of them. After coming back to Lebanon in 2014, he started to attend history courses at Saint Joseph University in Beirut in order to get a degree in History-International Relations. In conjunction, he started to make extensive personal research about the war of his youth in the different local archives and resources that were available online. Later, the subject of the Great War thrilled him and he started researching about the Great Famine of 1915-1918 in Lebanon and writing short articles about British-Ottoman war in the Middle-East for a YouTube channel called The Great War: Lest we forget! In 2020, he participated in writing the official book of the University about the Centennial of Greater Lebanon (1920-1926). In 2021, Lebanon and Australia will commemorate the 80th anniversary of the Syria-Lebanon Campaign of WWII; and Rabih is still as excited as ever for the uncovering of the forgotten marvels of his country's history!

Introduction

Summarizing the history of the cultural role of Beirut is a restless endeavor since Beirut is an Ancient city that was continuously inhabited and played the same role across the different empires for millennia. Indeed, its ever unchanged geographical location as the gate to the Levant earned Beirut the honor to host prestigious institutions and transformed it into a hub for regional culture.[1] This is why we chose some of the most memorable facts of Beirut's cultural heritage in the same careful way a lover selects/picks the flowers to create a personalized bouquet for his loved one.

Glances at Culture in the Long History of Beirut

Evidence of Ancient Music

There is numerous scientific evidence of culture in the ancient world. Luckily for Beirut, we hold evidence of singing and playing music in this city since the 15th century BC. Indeed, the flute, the horn and the lute ('oud) were among the most used for religious celebrations or war.[2]

The Roman School of Law and the Jealousy Mosaic

The Roman emperors greatly contributed to Beirut's fame in the ancient times, as it hosted a Roman School of Law. Historians still debate when this glorious institution was established and the identity of the emperor who decreed it, whether Julius Caesar, Alexander Severus, Lucius Septimius, or others, between the 3rd century BC and the 3rd century AD. However, they all declare that it was a long lasting institution who got the acknowledgement of the known world and surpassed, in global reputation, the other law schools established in Alexandria, Palestine, Damascus, Athena, Constantinople, and

1 Taleb et al., *Al Hanin ila Beirut* (Beirut: Perfection, 2015), 41.

2 Taleb et al., *Al Hanin ila Beirut*, 57.

even Rome. For instance, one of the famous lawsuits held in Beirut in the Antiquity was the case waged by King Herod against his two sons after their conspiracy to overthrow him.[3] The Byzantine era inherited the long law tradition of Beirut. The Syrian historian of the Arab Nahda (the Arab Renaissance in the 19th century), Muhammad Kurd Ali said that the Byzantine Emperor Justinian praised Beirut to such an extent that he surnamed it « the Mother of Laws and Nutrix of Sciences». He established in Beirut the third prominent teaching institution of his empire, following the University of Rome and the University of Constantinople.[4] The Beirut National Museum exhibits stunning evidence of refined culture during the above mentioned eras, especially the Hellenistic, Roman, and Byzantine eras, such as widespread statues and mosaics, especially the notorious Jealousy mosaic.[5]

The End of an Era

However, the fate of the millennial city including its School of Law and all the Phoenician, Egyptian, Hellenistic, Roman and cultural aspects temporarily vanished after a series of earthquakes, fires and tsunami that occurred during the 6th century. This explains why the Islamic historiography does not elaborate on the conquest of Beirut, because the new masters found more of a village than a classical roman city in place of the old Berytus.[6]

The Missed Islamic Opportunity of Rebirth of the City

However, after the Islamic conquest, the city slightly regained its status and fame thanks to the great Imam of Beirut, Abdul-Rahman al-Ouzaï, who is still acknowledged by the Christians of Lebanon as their successful defender against the persecution that their ancestors endured from the wali (governor) of Damascus. That being said, al-Ouzaï was, first of all, one of the most prominent Muslim scholars of his time and as such, he

3 Taleb et al., *Al Hanin ila Beirut,* 73.
4 Taleb et al., *Al Hanin ila Beirut,* 34.
5 *Musée National de Beyrouth,* museebeyrouth-liban.org/en.
6 Taleb et al., *Al Hanin Ila Beirut,* 97.

contributed in general to the renewal of the cultural hub in Beirut. Indeed, the influence of his teachings flourished not only in the whole of Syria, but also extended to the Maghreb and Andalusia during the 8th century AD.[7] Unfortunately, the disciples of al-Ouzaï never managed to develop a unified corpus of his teachings, hence, never institutionalized his way into a regular long-lasting Islamic school of thought. By the next few centuries, his teachings faded away and were outdated by the other Sunni schools like Shafi'i and Maliki schools that are, nowadays, widespread among Muslims.

Beirut Castle Culture under the "Old Lord of Beirut"

For most of the Crusades, Beirut became the home of the Frankish Ibelin family. Their most prominent heir was John of Ibelin, called the Old Lord of Beirut, for he rebuilt the city in 1197, because it had been partially destroyed by its Muslim defenders, including its walls and fort, after the Crusaders progressed towards the town coming from Palestine.[8] He also built an opulent palace for himself and decorated it with fresco paintings and mosaics on the floors that bore both Muslim and Byzantine influences.[9] In the courtyard, a marble fountain with a dragon-like centerpiece stood in the central hall to cool the air. Moreover, the murmur of the water gave an altogether soothing effect. A German chronicler was stunned at the sight of the public rooms which had the trompe l'oeil effect of sea and sky. This was achieved with marble inlays for the floor resembling the sea and life-like paintings for the ceiling.[10] Unfortunately, when the Crusaders were expelled by the Mamelukes in the 13th century, Beirut was supplanted by other coastal towns like Sidon and her cultural appeal faded away again.

7 "Abdul Rahman Al-Ouzai," *Wikipedia*, https://ar.wikipedia.org/wiki/عبد_الرحمن_الأوزاعي#cite_note-78;
Mohamed Ould Mohamed Fal Ould Tidjani, "الفقه المالكي في بلاد الغرب الإسلامي: تاريخه، نشأته ومراحله," Mominoun Without Borders, April 29, 2014, https://www.mominoun.com/articles/-482الفقه-المالكي-في-بلاد-الغرب-الإسلامي-تاريخه-نشأته-ومراحله

8 Taleb et al., *Al hanin ila Beirut*, 117.

9 Kenneth Setton, *A History of the Crusades* (United States: University of Wisconsin Press, 1985), 142, https://archive.org/details/historycrusadesv00sett_654

10 P. W. Edbury, *John of Ibelin and the Kingdom of Jerusalem* (United Kingdom: Boydell Press, 1997), https://archive.org/details/johnofibelinki00edbu

Renewing Beirut's Castle Culture under the New Lord of Beirut

Beirut's cultural aspect was improved a few centuries after the Crusades, during the early Ottoman era, under the first local prince who unified the Lebanese territories under his rule: Fakhreddin Maan II the Great. This Druze ruler dared to welcome the Western world not only by inviting architects and specialists from Tuscany to his principality, but also by paying a visit to the Italian Medici's Grand Duchy of Tuscany and the Spanish possessions of Sicily and Naples. On the local Syrian and Lebanese level, although he chose Sidon as a base, he built himself a castle in Beirut and planted orchards around the town. Moreover, the famous pine forest around Beirut is said to have been extended by Fakhreddin in order to stop the rampant sand dunes south of the town. The Emir's palace in Beirut was designed in the Italian style adapted to local wishes with a rectangular courtyard, which was furnished with colorful mosaics, ornate marble fountains, vast gardens, stables, and a reserve of wild animals. Unfortunately, this landmark fell into ruins in the 19th century.[11]

Beirut Trade and Cultural Rebirth

In 1831, the Egyptian troops of Ibrahim Pasha occupied the Ottoman Beirut and made it their base for Lebanon and Syria. The pro-French conqueror undertook major works in the town, including the fitting out of her seaport, which led to tremendous growth of the steamboat traffic.[12] Therefore, Beirut became a thriving trading center especially for silk between Mount-Lebanon and Egypt.[13] The work of modernization did not end with the departure of Egyptians in 1840, and the restoration of Ottoman sovereignty, but it continued through other great site works mainly made by the French. As a matter of fact, the openness to European culture was already rooted among the local elite, as one

11 Elie Haddad, "Between Myth and Reality: The 'Tuscan Influence' on the Architecture of Mount Lebanon in the Emirate Period," *Journal of Design History,* vol. 20, no. 2 (2007): 161-171, http://www.jstor.org/stable/4540351
12 Ouanassa Siari Tengour, "Samir, KASSIR, Histoire de Beyrouth," *Insaniyat,* online since August 2012, accessed on January 28, 2021, 35-36, https://doi.org/10.4000/insaniyat.3927
13 W. Harris, *Lebanon: A History,* 600 – 2011 (London: Oxford, 2014).

Jesuit missionary wrote in 1833 to his superiors in Rome asking them to send "good treatise on building and the arts and crafts in general" because "the Arab Emirs always request from us explanations on the subjects of arts".[14] In parallel, the Arab cultural Renaissance or "Nahda" accelerated its pace in the wake of Muhammad Ali Pasha's departure from the Levant and culminated at the end of the 19th century. Beirut, Cairo, Damascus, and Aleppo were their main centers. Academies of Arab language, urban clubs of literate people, tremendously developed. The first modern Arab printed presses were established and Beirut was pioneering in this regard. Music, sculpture, history and human sciences in general developed; translation of western sources was particularly active, including the arabization of the new scientific terms such as "electricity" and "magnetism". The ideas of human rights that arose from the French Revolution and the right of women to literacy have been widely spread. Nassif Yazigi and Boutros Boustany are two prominent figures of the Nahda movement who had strong ties with Beirut. Both distinguished themselves – among other things – in translating the Bible into Arabic with the help of the Orientalist missionaries of the Syrian Protestant College in Beirut, the Van Dyke version of the Bible which is still acknowledged to this day.[15] Boutros Boustany also established the first Arabic non-religious/secular school in Beirut and wrote the first Arabic Encyclopedia.[16] At the turn of the 20th century, there were 18 presses in Beirut, 2 university libraries, 5 public libraries, 16 newspapers, and 10 magazines.[17]

14 Haddad, "Between Myth and Reality," 161-171.
15 M. Moosa, *The Origins of Modern Arabic Fiction* (United States: Lynne Rienner Publishers, 1997), 124, https://books.google.com.lb/books?id=itz5_UEKSZUC&pg=PA124&redir_esc=y#v=onepage&q&f=false
16 Omar Tamo and George Azar, "Cabinet formation faces a new potential obstacle as politicians link funding for electricity to reforms," *L'Orient-le-Jour*, accessed May 1, 2019, https://www.lorientlejour.com/article/1168596/boutros-boustany-itineraire-dun-enfant-de-la-nahda.html
17 Karl Baedeker, *Palestine et Syrie, routes principales... Chypre, manuel du voyageur, 4th Edition* (Leipzig, 1912), https://gallica.bnf.fr/ark:/12148/bpt6k203297k

Beirut and the First Theatrical Performance

The 1st classical theatrical performance in Beirut was held at the Naccache residence in 1847, nowadays transformed into a church in Gouraud street, Beirut. It was the Arabic adaptation of the famous French play The Miser (L'Avare) by Molière (1668).
The adaptation was written by Maroun Naccache, a Christian from Lebanon who was considered the godfather of modern Arab theatre.[18] However, one must wait 6 decades to witness the opening of the first cinema theaters in Beirut. Indeed, early in the 20th century, the literate citizens could already read advertisements about silent movies in the last page of their local newspapers, like this prewar Christmas ad of 1913 offering a free ticket to Cinema-Gaumont theater on Damascus street in exchange of purchasing articles from Orosdi-Back, the first large scale department store in Beirut.[19] A decade later, in 1925, the first fictional movie ever to be shot in Beirut, La Châtelaine du Liban, was made by the French film director Marco de Gastyne and had fair success in Paris and contributed to the fame of the young French actress Arlette Marchal.[20]

The Vitrine of French Culture in the Ottoman Empire

Westernization of the medieval town of Beirut became an irreversible process in the second half of the 19th century. As a matter of fact, French language progressively replaced Italian as the foreign language spoken by the Levantine educated people. In 1888, Beirut city was granted the status of the head of an Ottoman Vilayet, or

18 "Meeting with Christina Lassen," *Agenda Culturel,*
https://www.agendaculturel.com/article/Scene_Rencontre_avec_Christina+Lassen; Ibrahim al Yaziji, "Wake up Arabs," *Lecture 7: Arabic Cinema* (Ontario: University of Ottawa),
https://www.coursehero.com/file/p7jn68k/Ibrahim-al-Yaziji-1847-1906-Wake-Up-Arabs-inhadou-ayouhal-al-arab-2-Media/;
"Monuments in music - A show by Henry le Bal on April 10 and 12 'The seven words of Christ' in the Terra Santa church in Gemmayzé," *L'Orient-le-Jour*, April 8, 2006, https://www.lorientlejour.com/article/528611/
19 Ad appearing in Le Reveil magazine, December 27, 1913, p.4; accessed in L'Orient-le-Jour archives, https://lorientlejour.com/archives.
20 "Autour de 'La Chatelaine du Liban'," *Ciné-Journal: Organe Hebdomadaire De Cinématographique / Directeur Georges Dureau,* (August 28, 1925), https://gallica.bnf.fr/ark:/12148/bpt6k46503813/f21;
"La Châtelaine du Liban," *Cinéa*, October 1, 1926, https://gallica.bnf.fr/ark:/12148/bpt6k5739083k/f9.

province, and was surnamed "the jewel in the crown of the Padishah" by the German Kaiser Wilhelm II when he visited it in 1898.[21] French were very eager to modernize Beirut, their "centre de rayonnement de la culture française", or in other terms, the center of radiance of the French culture.[22]

The Deep-rootedness of the Modern Education Sector in Beirut

The education sector boomed in the emirate of Lebanon since the beginning of the 19th century. Nevertheless, it was in the second half of it that Beirut regained, once again, the role of cultural hub. Indeed, dozens of Christian religious missions, one Jewish mission, numerous Christian, Muslim and Druze local sects, and even a few secular initiatives established their own schools and universities to broadcast their beliefs and ideas, along with literacy and sciences in Lebanon, Syria, and the Ottoman Empire, and beyond. At that time, education was largely influenced by French and American systems and open to girls.[23] After the war and at the onset of the French Mandate for Lebanon and Syria, the education sector was restored in Beirut and standardized according to the French system. By 1921, there were 923 schools in the new Lebanese State,[24] mainly located in Beirut, for one fifth[25] of a population of slightly more than half a million people.[26] Naturally, this trend reflected on the repartition of schools in the capital of Lebanon.

21 Nadine Hindi, "La transformation urbaine de la ville de Beyrouth," *Méditerranée*, no. 131 (January 2020), https://doi.org/10.4000/mediterranee.11486.

22 Hindi, "La transformation," *Méditerranée*.

23 Emile Larose, ed., *La Syrie et le Liban en 1921: La Foire-Exposition de Beyrouth. Conférences. Liste des récompenses* (Paris: Haut Commissariat de la République Française en Syrie et au Liban, 1922), 113-120, https://gallica.bnf.fr/ark:/12148/bpt6k5609204k.

24 Larose, *La Syrie et le Liban en 1921*, online.

25 Samir Kassir, *Histoire de Beyrouth* (Paris: Fayard, 2003), 31.

26 Thibaut Jaulin, "Démographie et politique au Liban sous le Mandat," *Histoire & Mesure*, No. XXIV - 1 (2009): 189-210, https://doi.org/10.4000/histoiremesure.3895.

The Establishment of Modern Universities in Beirut

Two dates are to be remembered for education and culture in Beirut in the 19th century: 1866 and 1875. Indeed, two prominent protestant and catholic missions founded the Syrian Protestant College and Saint Joseph University,[27] both in Beirut and 2 kilometers apart from each other. Interestingly, the angular stones of both institutions were their Schools of Medicine. Half a century later, the SPC [renamed in 1920 the American University of Beirut or AUB] hosted more than a thousand students and nearly two hundred professors from 14 nationalities from 4 continents, and boasted a museum hosting 25 Phoenician sarcophagi,[28] an astronomical observatory[29] and a library filled with 25,000 volumes. In parallel, Saint Joseph University held several faculties, laboratories, an astronomical and meteorological observatory, museums and a library of 32,000 volumes.[30]

The Creation of the National Library

The National Library of Lebanon had a father: Viscount Philippe de Tarrazi. Indeed, the project evolved like a child who was nurtured by the dreams of his founder. At first, in 1919, de Tarrazi founded the "Book House" in his residence with his own personal collection. Then, he moved his fast-growing collections of 20,000 printed documents and 3,000 manuscripts in several languages to the building of the Prussian school known as the Deaconess School in Beirut in 1921. The library was then renamed "Grand Book House." In 1922, the House was recognized by the authorities and De Tarrazi was

27 "About Us," American University of Beirut, http://www.aub.edu.lb/AboutUs/Pages/history.aspx; "History," Saint Joseph University - Beirut, https://www.usj.edu.lb/universite/historique.php?lang=2.

28 G. Contenau, "Le Congrès international d'archéologie de Syrie-Palestine," *Syria: Archéologie, Art et histoire*, vol.7 (April 1926): 257-270, https://doi.org/10.3406/syria.1926.3173.

29 Oriental Institute of the University of Chicago, "The Breasted's 1919-1920 Expedition to the Near East," photographic archive (Chicago: The University of Chicago Press, 1978), http://oi-archive.uchicago.edu/museum/collections/pa/pioneer/beirut.html.

30 Berger-Levrault, ed., *La Syrie et le Liban: Sous L'occupation et Le Mandat français: 1919-1927* (Paris: Haut Commissariat de la République Française en Syrie et au Liban, 1927): 124-133.

appointed as Secretary General. In 1937, the library now holding some 32,000 books moved to the parliament building. At the time he resigned, "his" collections had increased to about 200,000 books or manuscripts, as well as a unique collection of archives such as administrative and historical documents left by the Turks in 1918 and valuable works of art. As such, the library became a hub for the students, teachers, and university libraries.[31]

The Booming of Feminine Clubs in Beirut

As previously mentioned, the Arab Renaissance had a positive impact on the female community of all the Lebanese religious denominations. In the late 19th and early 20th centuries, feminist clubs developed in the Levant, but they had a significantly higher occurrence in Beirut city. Educated women very often gathered to discuss literature, poetry, mundanity as well as the politics amidst the deep transformations that shook the Ottoman Empire at that time.[32] The names of the clubs embodied the aspirations of the Arab woman back then, such as "Yakzat al-Fatat al-Arabiya" (the awakening of the Arab woman), "Al-Tahdhib" (cultivation), "Al-Nahda" (rebirth). Some feminists became famous through literature and journalism by tackling the modern issues of women. Feminists' clubs survived the Great War and thrived again under the French administration. On the political level, they notably took part in signing petitions to the King-Crane Commission of the League of Nations in 1919 to advocate the political demands of the societies they came from.[33]

31 Cendrella Habre, "The Story of the Lebanese National Library," International Federation of Library Associations and Institutions (IFLA), last modified 27 March 2019, http://www.ifla.org/FR/node/92071.

32 *Le Temps*, no. 21550 (August 1, 1920): 3, https://gallica.bnf.fr/ark:/12148/bpt6k244089m

33 "Petition from Muslim women of Beirut," *King-Crane Commission Digital Collection*, http://dcollections.oberlin.edu/cdm/singleitem/collection/kingcrane/id/1863/rec/35.

The Sudden Cultural Freeze in Beirut in WWI

World War I was catastrophic for Beirut at all levels; needless to say, the culture suffered enormously as people's attention was diverted to the basic needs of life i.e., food and shelter, in the scope of repeated shortages and the famine that harshly hit Lebanon and Beirut. Trade with Europe was interrupted, banks were closed down, and communications with the Syrian interior ceased.[34] During this time of acute crisis, Saint Joseph University and the rest of the Allies' related institutions were closed, controlled, seized, or converted into other roles by the local Ottoman military authorities led by Ahmed Jamal Pasha nicknamed "the butcher" by the Levantines. However, the Syrian Protestant College was spared thanks to the neutrality of the USA until 1917. Even after the USA and the Ottoman Empire declared war, this institution remained a safe haven[35] and a humanitarian hub for all the Near-East persecuted people for the rest of the war, even gaining the recognition of the same Jamal Pasha[36] after providing, willy-nilly, solid medical support for his administration.

The Beirut International Exhibition of 1921

In the aftermath of WWI and the ensuing victory of the Allies of the Entente, and the French administration of Lebanon and Syria, the French High Commissioner General Henri Gouraud played a great role in reviving the cultural role of Beirut city. One such event is worth mentioning: the Beirut International Exhibition of 1921. Indeed, the French wanted to develop the trade between France and the newly administered territories referred to as "mandate" rather than "colonies" by the League of Nations. The

34 Larose, *La Syrie et le Liban en 1921*, online.
35 "Speech by AUB President Fadlo R. Khuri, MD," American University of Beirut, hosted by *Northern California Chapter Speech*, (February 15, 2020),
https://www.aub.edu.lb/President/Documents/speeches/2020/NorthernCA_Feb152020.pdf#search=world%20war%20one.
36 "150th Birthday Celebration: President Fadlo R. Khuri Remarks," American University of Beirut, (December 7, 2016),
https://www.aub.edu.lb/President/Documents/150-birthday-celebration.pdf#search=world%20war%20one.

French wanted to create a memorable event which would contribute to restoring the pre-war French influence in the region. In April 1921, downtown Beirut was transformed into a giant open air exhibition and fairground under the century-old trees of Beirut amid hundreds of international flags and neat lawns. Public gardens were planted with carpets of scarlet-red and royal-blue blossoms. Some 350 shops offered the articles of the western and Levantine houses in the midst of the stands. Everything was displayed, from automobiles to toys, by more than a thousand companies from a dozen countries including the United States of America who showcased American automobiles, farming tractors, canned food, gramophones, and sewing machines. The Levantine shops showcased furniture, pastry, wine, spirits, silk products, cotton products, embroideries, carpets, olive oil, soap works, glassware, jewelry, tobacco, and many varieties of local fruits. Last but not least, the pavilion of fine arts displayed the works of renowned Lebanese artists like Salibi, Corm, Srour, Sursock, Omsi, Hoyek, Debs, etc. Even China made an appearance by presenting a dragon dance at the Hippodrome of Beirut.[37]

The Golden Days of Archeology in Beirut

After WWI, the Near East, including Beirut, became an increasingly interesting destination for archeologists. For instance, the city was on the trail of the daring American 1919-1920 Breasted Expedition to the Near East.[38] Later on, in 1926, Beirut gained significant importance by hosting the opening session of the International Archaeological Congress in Palestine and Syria and centralizing its activities in Lebanon and Syria. More than 81 interested groups coming from 12 countries attended, representing their respective universities, colleges, seminaries, exploration organizations, learned societies, governmental departments, libraries, museums, and publications.[39]

37 Larose, *La Syrie et le Liban en 1921*, online.
38 Oriental Institute of the University of Chicago, "The 1919-1920 Breasted Expedition to the Near East" (Chicago: The University of Chicago Press, 1978),
https://www.bookdepository.com/1919-1920-Breasted-Expedition-Near-East-Oriental-Institute/9780226694733
39 "International Archeological Congress in Syria and Palestine: A Letter from His Majesty King," *Bulletin of the American Schools of Oriental Research*, Vol. 23 (October 1926): 29, https://doi.org/10.1086/BASOR1354960

The congress participants had the rare opportunity to watch color screenings of the sites they were going to visit made by Albert Kahn, the creator of the amazing photographic project called the Archives of the Planet.[40]

The Foundation of the National Museum of Beirut

In 1919, the French High Commission created the Department of Antiquities and Fine Arts. Its main attribution was to create archaeological museums. The French also launched a permanent archaeological mission in Syria, which executed numerous archeological excavations.[41] In parallel, the collection of archaeological artifacts began on the initiative of Major Raymond Weill who exposed them in a room of the German Deaconess School in Beirut. This proto museum was reorganized and was officially opened in 1923. The products of the excavations that had been carried out from 1920 to 1923 were collected and classified there. They came from Kadesh, Tyre, Sidon, Byblos, Aleppo, Beirut, Rouad, Latakia, Hama, Ras El Aïn, and other places in Lebanon and Syria as well. Fortunately, the archaeological missions increased and they dug out more discoveries than ever. Therefore, plans for a new museum were drawn up. Works started in 1930 but were interrupted by World War II. Then, works were resumed and the current Egyptian styled building of the National Museum of Beirut was inaugurated in 1947.[42]

40 Contenau, "Le Congrès international d'archéologie," online, 257-270, https://doi.org/10.3406/syria.1926.3173
41 Berger-Levrault, *La Syrie et le Liban*, 139-143.
42 Charles Virolleaud, "Rapport annuel sur les travaux archéologiques en Syrie et au Liban," *Comptes rendus des séances de l'Académie des Inscriptions et Belles-Lettres*, no.4 (1928): 329-330, https://doi.org/10.3406/crai.1928.75657;
Charles Virolleaud, "Les travaux archéologiques en Syrie en 1922-1923," Syria, vol.5 (2) (1924): 113-122,
https://doi.org/10.3406/syria.1924.3036;
Mathilde Rouxel, "De nouvelles salles accessibles au public au musée national de Beyrouth," Les Clés du Moyen-Orient, last modified February 3, 2018,
https://www.lesclesdumoyenorient.com/De-nouvelles-salles-accessibles-au-public-au-musee-national-de-Beyrouth.html;
"Inauguré en 1947," Introductory video, National Museum of Beirut, 23:08, http://www.museebeyrouth-liban.org/; "The National-al Museum of Beirut," YouTube video, 6:07, posted by AnnaharTV, September 12, 2009,
https://www.youtube.com/watch?v=DTO3sgYFKaA.

Conclusion

No further light needs to be shed on the cultural history of Beirut in the 20th century because it is well recorded thanks to the media. Hence, we won't emphasize it. Indeed, Beirut continued to play a major role as a bridge between the East and the West, especially in the newly formed group of Arab Nations in the post colonialist era. The trend of westernization and cosmopolitanism remained vivid and the million people capital city of Lebanon became a regional platform for Arab artists and writers, and an appreciated stopover for many western artists including Americans. While some celebrities fell in love with Beirut like Anthony Bourdain,[43] others actually performed in Beirut in the recent years like Luciano Pavarotti,[44] Ricky Martin,[45] Bryan Adams,[46] Chris De Burgh,[47] Elton John,[48] Yanni,[49] and international bands like the Scorpions,[50] Guns N'Roses,[51] and others.

43 Jason Lemon, "7 Times Western Celebrities Had a Lot of Love for Lebanon," StepFeed, last modified on May 24, 2017, https://stepfeed.com/7-times-western-celebrities-had-a-lot-of-love-for-lebanon-9005.
44 "Pavarotti Sings in Beirut," *The Irish Times*, last modified on June 19, 1999, https://www.irishtimes.com/news/pavarotti-sings-in-beirut-1.195520.
45 "LEBANON: Latin Pop Star Ricky Martin Performs His First Middle Eastern Concert in Beirut," Reuters Archive, https://reuters.screenocean.com/record/225165.
46 "Bryan Adams Live Concert in Beirut, Lebanon," Lebtivity, https://www.lebtivity.com/event/bryan-adams-live-concert-in-beirut-lebanon.
47 "Chris De Burgh Concert in Lebanon - Part of Beirut Holidays 2017," Lebtivity, https://www.lebtivity.com/event/chris-de-burgh-concert-in-lebanon-part-of-beirut-holidays-2017.
48 "Elton John in Concert in Lebanon at Byblos International Festival," Lebtivity, https://www.lebtivity.com/event/elton-john-in-concert-in-lebanon-at-byblos-international-festival.
49 "Yanni Live in Concert at Beirut Waterfront - Part of Beirut Holidays," Lebtivity, https://www.lebtivity.com/event/yanni-live-at-beirut-waterfront.
50 "Scorpions Live in Concert in Beirut, Lebanon," Lebtivity, https://www.lebtivity.com/event/scorpions-live-in-beirut-lebanon.
51 "Guns N'Roses Live in Concert in Lebanon!," Lebtivity, https://www.lebtivity.com/event/guns-n-roses-concert-lebanon.

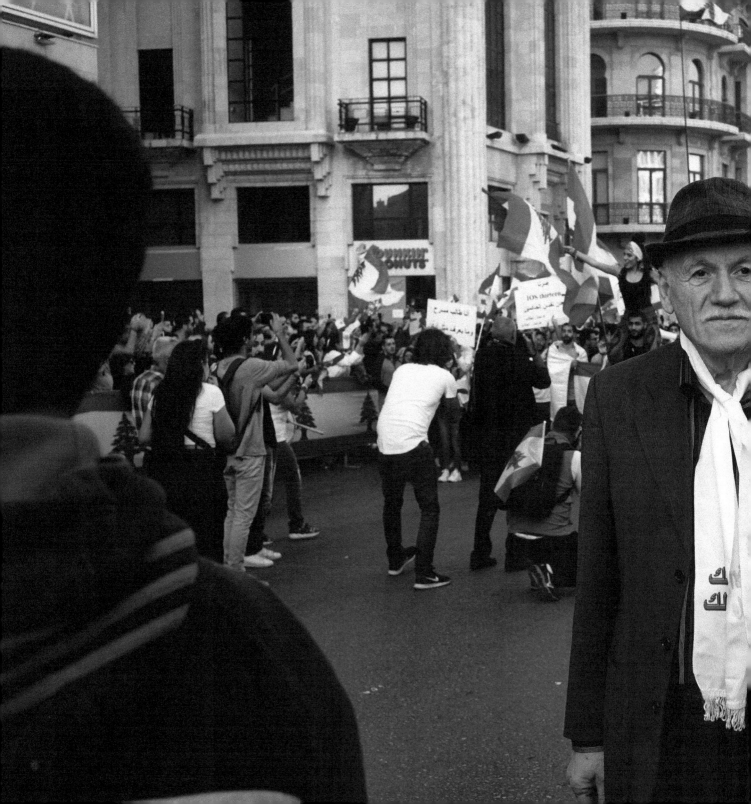

Into the Frame: An old man, tired of history repeating itself in Lebanon, poses for a candid portrait on Independence Day 2019, almost a month after the start of the October 17 uprising.

KATIA AOUN HAGE

Beyond the screen in my palm

Born in Cameroon and raised in Lebanon during the civil war of 1975, Katia Aoun Hage moved to the United States where she resides with her husband and three children. Katia graduated from the University of Redlands with a Masters in Music Education, so she is not a stranger to the Inland Empire's art scene of Southern California. She has collaborated with choreographer Sofia Carreras at Riverside Community College, performed poetry and music at California State University, San Bernardino, displayed her artwork at Art for Heaven's Sake, and performed music in several local venues. Katia Aoun Hage listens deeply to the voices inside, of her own people and hers, becoming a bridge between past and present, and between east and west, through her poetry, translations, and artwork. In 2019, Katia founded Elyssar Press based in Redlands, where she is now publishing books by artists and writers from around the world.

the screen in my palm
holds the world
news flooding in
smoke
fire
a mushroom of explosion

the screen rattles
it breaks
screams of horror
sirens of responders
white shrouds
covering bodies
laying on the streets
amongst rubbles
ancestral homes
crumbling to the ground
shards of glass
everywhere
history erased
in a matter of seconds
a tribute to the fragility
of everything human
life
disappears
in the silence
of suddenness

the screen rattles
it creaks
in a trembling palm
it holds everyone
miles apart

i call upon my kin
do you see
the horror of it all
i play over and over again
the instagram videos
the facebook links
the one where the buildings shake
the one from the street view
the one from the boat view
the one immense mushroom cloud

enveloping the entirety
of Beirut
the before and after photos of the Beirut port
gone
ships
vanished
silos
leveled to the ground

the screen lists numbers
of family and friends
names sift through my fingers
my memory of where they live
places of their work

011 - 961 -

aloo beirut?

011 - 961 -

my heart skips a beat
before hearing the familiar voice
i was at home
i just drove back on that road
we decided not to go to Beirut
i left work late
we had a day off
all my co-workers died
we don't know what happened
we don't know what
we don't know
we don't
we

despair

we
we want
we want to
we want to leave
we want to leave our country

the screen rattles
it shakes
voices flooding in
tremulous
weeping
i want to get away
there is no future
they are killing us
who would do such a thing
this is unbearable
unimaginable
a catastrophe
no one listens
no one hears
no one does

the screen fills with faces of loved ones
i try to touch them
with my words
my breath syncs with theirs
my gaze holds them
tucks them in my heart
i listen to their pleas
pendular emotions
from gratitude
to anger
from sadness
to distress

the screen turns red
a stream of blood
running down streets
all the streets of beirut
the river of adon [1]
floods southward
sweeping with it
limbs and dreams
to join the sea

1 The river south of Jbeil called Nahr Ibrahim and known as the river of Adon or Adonis

ashtarut[2] weeps for her lover
killed mercilessly
she carries cadavers
in her arms
wailing
for the loss
of the one she cared for
over a myriad of years
she fell for his beauty
enchanted by his loveliness
until the wild boar
dragged him motionless
adonis dies once more
trawling with him the multitude
surrounded by grief
women beating their breasts
at the sorrows
befalling them
ashtarut is inconsolable

my screen rattles
it shakes
i recount the stories to my friends
a button pushed on repeat
of the same scene
the same story
they ask me how to help
a way to lend a hand
to give relief

how do we embrace a world
falling apart

i turn off my screen
everything disappears
as if it never existed
my reality is as strange
as my imaginings

2 Astarte (/əˈstɑːrtiː/; Greek: Ἀστάρτη, Astártē) is the Hellenized form of the Ancient Near Eastern goddess Astoreth (Northwest Semitic), a form of Ishtar (East Semitic), worshipped from the Bronze Age through classical antiquity. The name is particularly associated with her worship in the ancient Levant among the Canaanites and Phoenicians.

my numbness is delirious
quietude staggers upon
uproar
the skies invite my heart
to sit
calm the aching
breathe
find myself in the midst of the many
who struggle
yet disconnected
from all their pain
in a bubble
of comfort

is my life an act of treason

the screen lights
it calls
notifications of a child found
a nurse saving infants
youth cleaning the streets
people helping people
colors emerge
of a rainbow
made by acts of compassion
ashtarut awakens from her grief
to hold her one and only
adonis
with her tears
she flows life back
into his body
invites him back
into a new reality
where he has to live
in the abyss
be in her company
and choose a time for himself
adonis is changed
forever
he is not the youth
he used to be
but one who seeks
his hidden face

to usher it into the light
one who understands
the overbearing forces to be released
one who faces
his deepest fears
to dispel their disillusions

our society changed
forever
our universal presence
a testimony of endurance
our movement
a spring from the depth
of all our hearts
that streams continuously
looks beyond the adversity
to the immensity of life
enveloping
all the cycles
of death and rebirth
allowing us
to understand the meanings
of our nature
our capacity for destruction
 and
our potential for creativity

trust

LINDA TAMIM

A story to tell

Linda Tamim is a journalist and radio broadcaster based in Beirut, Lebanon. She grew up in Mali, West Africa and moved to Beirut in 2003. Shortly after earning a BA in English language from the Lebanese American University, Linda worked as a language editor and taught English to a variety of students young school-children, young professionals, high ranking military officials, retired people, and refugees. Her career in the media kicked off when she started working as a news presenter, producer and reporter for Future TV English. Today, Linda hosts the morning show on Virgin Radio Stars and works as a freelance journalist. She is also a presenter at DNBC TV. She reported for several news stations including France 24, TRT World, SkyNews and 7NEWS (Sydney). In her spare time, Linda enjoys cooking/baking, working out, reading and spending time with her dogs.

I've always had a love-hate relationship with Beirut, this city I've called home ever since I moved to Lebanon in 2003. Sometimes, the feeling of love prevails; other times, I hate it so much that I curse the fact that I was born here... yet at times, both feelings rage simultaneously so deeply in my heart and it's hard to make sense of how I feel about this place.

Whenever I'm away, I long for the authentic taste of hummus and tabbouleh (as cliché as this sounds), for the warm smiles and hellos of neighbors I cross on the street, for being able to get my groceries from the little "dekkene" (neighborhood store) across the road, for short distances, for the beautiful weather, for coffee time or happy hour with good friends, for this joie de vivre and social life we are envied for... Ah, Beirut... it does get under your skin. Some call it a curse, others a blessing; heaven on earth... or hell.

Blackouts during hot summer days and nights, water and electricity shortages, never-ending traffic, the deafening sounds of car honks, motorcycles, trucks and construction work, people yelling, the smell of exhaust and garbage filling our lungs are all part of our daily lives. And did I mention corruption—the root cause of everything going wrong in this country... and I mean everything. Fawda, a term referring to a state of chaos, is the way to live. Wasta, or nepotism, is the way to get a job no matter your qualifications. Rules, if enforced at all, don't apply to you if you're related to some politician or za'iim. Yet many Lebanese, and dare I say the majority, seem to normalize all those notions and even worse, comply with and accept them. Most people refer to this as "Lebanese resilience"; personally, I loathe this term because to me, it's not resilience, it's conceding and remaining passive in the face of constant political, economic, bureaucratic, environmental and physical abuse by a class of corrupt leaders and some fellow citizens alike. This passiveness is beyond anything I could ever comprehend.

The revolution of October 17, 2019 was a major turning point for those who were exasperated by the situation and who wanted to overturn the system. The outcome of the movement is debatable; some say that the revolution failed since the political class it had

aimed to overthrow is still in place, and the country has been sinking deeper into a series of multiple crises ever since. I believe that the revolution triggered a shift in the people's mentality, however small that shift might be. When a seed is planted in soil, it takes months if not years for it to grow into a tree. Similarly, I see the October 17th uprising as a seed which, in decades to come perhaps, will give birth to a new Lebanon.

As a journalist, I guess it's fair to say that Lebanon is the perfect place to be. Flocks of reporters and news correspondents from around the world have made it their base since the Lebanese Civil War, to report not only on Lebanon but also on the instability and tensions around the Middle East. Despite being relatively safe compared to other countries in the region, Lebanon is rocked by a major, often catastrophic event (or events!) every few years: a civil war, a war with Israel, a bomb targeting a political figure, ISIS threats and attacks, a ponzi scheme followed by hyperinflation, capital control and a massive economic crisis... Recently, it all culminated with one of the most powerful explosions in the world—likely caused by negligence from the government—and a surge in COVID-19 cases, pushing an already fragile health sector to the brink of collapse. Could things get any worse?

I was born during the civil war, precisely 5 years before it ended. While I have missed the horrors and tragedies of that period (notwithstanding a bullet landing on the pillow on which my infant self was resting), I haven't missed most of the major events mentioned above. And I was in Beirut on August 4, 2020—a date forever engraved in the memories of those who lived it, of those who lost loved ones, of the many ones like myself who had a narrow escape, and of those who miraculously survived.

I had worked later than usual that day. I would normally be home—which faces the port where the explosion happened—by 4 p.m., but that day I remember checking the time on my computer. 5:55 p.m. *What am I still doing here?*, I thought, as I was ordering an

Uber ride back to Gemmayze. I got into my cab at 6:03 p.m. Four minutes later—and a 10 minute drive away from the port, I was thinking about what I could have for a late lunch when I saw what appeared to be a reflection of pink lights in the clouds. Before I could even attempt to make sense of what it could be—not that anyone could have guessed what it was or what was just about to happen—a deafening sound pierced through my ears and shook the whole world around me. Like everyone else, I was in total shock, and in that moment, I realized I had never felt so vulnerable and helpless. I don't remember feeling such horror, not even when Israel was bombing us during the 2006 war, yet the first thought that crossed my mind was *Israel was attacking...Where is the next one going to land?...* Panic. Confusion. And a series of questions flowing through my head—*What was that? What do we do? Do we park the car and hide? Do we keep driving? Will another bomb land over our heads now? Is that it?* Of course, I had no answers to any of those questions. I was staring at this enormous pink and orange cloud which had formed in the sky shortly after the explosion when the driver, as confused as I was, asked me what to do. Without really thinking, I answered, "Keep driving."

As we drove on the highway leading to the port, roads were blocked and traffic was diverted. Looking at other people in their cars, I could only see panic and confusion. The driver had turned on the radio to listen to the news but we could only hear speculations. "An attack targeting former PM Saad Hariri... a gas explosion..." As we reached closer to the port, I was struck by the sight of destroyed buildings, shattered glass on the ground, and bloodied faces. I was in total shock. Little did I know what lay ahead...

We were now in Mar Mikhael, driving past more injured people, buildings in ruins, smoke and an ocean of glass debris. Then suddenly, people started throwing themselves at our car: "Please take us to the hospital!" I was absolutely horrified, but too shocked to react. Was this real? Mar Mikhail, one of the most vibrant districts of Beirut, my home for the last 4 years, had turned into a horror movie scene. *If this is a nightmare, someone please wake me up!*

A family carrying a woman who had fainted—the mother, I assumed—stopped us and begged us for a ride to the hospital. At that point, I had asked the driver to drop me off and take them; they needed the ride more than I did. I began walking; white lace shoes weren't ideal to walk on a muddy ground full of glass, but I had no choice. Dark clouds of smoke could be seen from the port, although we still had no idea what had happened yet. It was hard to breathe. People around me were crying, some were screaming. A wounded man was encouraging his limping dog to keep walking home... *Did he still have a home?*, I wondered. I saw bloodied faces and bodies—bodies everywhere on the ground, some were transported on what looked like DIY stretchers, others lifted by the hands and feet. *Were any of them dead?* The thought of it sent a shiver down my spine. There were a few ambulances, but not enough for so many injured. I've never witnessed such a chaotic scene in the 10 years since I've been a journalist. Instinctively, I had grabbed my phone and went live on Facebook, describing and showing the horror around me. In retrospect, I think I was trying to shield myself via observing what was happening through my camera's lens; seeing it first hand was too distressing. It wasn't long before TRT World called and asked me to report live from the scene— I was in the perfect spot for that after all. That phone call from Istanbul marked the beginning of the busiest and most hectic time of my journalistic career.

I was reporting live from the port area every single day for the entire month of August. There were times I'd work from 7 a.m. and not get home until 2 a.m. Sometimes, I'd barely have the time to eat and wash off the dirt, sweat and toxic dust which had accumulated on my body before changing into clean clothes and running to another assignment. Since August 4th, I talked about people losing their lives, their homes, and their jobs, and about the survivors' shattered hearts and hopes. I covered the physical and economic damage caused by the explosion; the volunteer-led efforts by the Lebanese people, mainly the youth, to clean up the debris and lend a helping hand to those in need, doing most of the work a proper functioning government should have done; and I covered the outpouring of foreign aid. I talked about and shared the anger and frustration at the corrupt political class held responsible for the blast, a class still shamelessly holding onto

power while ignoring the people's pain, and not even issuing a single apology. I reported on the cabinet's resignation in the wake of protests often turning violent; and ever since, I've been reporting on nothing else but Lebanon sinking deeper into an abyss of chaos and uncertainty. Most days, the adrenaline kept me going, but there's no denying that this frenzy took its toll at times. Burnout—both physical and emotional – was inevitable. Surviving one of the most powerful explosions in the world, not to mention a series of crises beforehand, is a traumatic experience. Reporting on these events on a daily basis is unnerving and demoralizing, and even more so when they happen in one's own country.

Luckily, I also happen to be a host for commercial radio, which turned out to be a blessing in disguise, especially through such bleak times. When things get too much, the studio is my sweet escape and a welcome reprieve. Before the surge in COVID-19 cases, I'd hosted local small business owners to boost their businesses, groups of people who'd launch initiatives to help those in need, and NGOs. I was delighted to meet so many inspiring individuals eager to lend a helping hand and make a difference in others' lives. Some were university students who were raising funds and donations to distribute food boxes; others were volunteers who would rebuild destroyed houses, provide medication or offer mental health support. One such example was an eyewear shop owner who provided eyeglasses for free to those who lost or damaged theirs during the explosion. A common thread that I noticed throughout these relief efforts was their contagious positive energy.

Seeing so much solidarity during such tough times was the silver lining to me. Most importantly, it reminded me that Lebanon's only hope lies in the generosity and kindness of its people. Those I've met or interviewed, young and old, and those who gave their all when they had nothing left are the ones giving me purpose today. As a journalist, it's their story I'd like to tell.

The Station: A view from the inside of the Charles Helou station in Beirut, built in 1972 and facing the port. It is an important hub for inner city travel to North Lebanon and Syria.

OULOU MALAEB

Fortunate Timings

Dr. Loulou Malaeb is an Assistant Professor of Humanities at the American University in Dubai, teaching philosophy and cultural encounters. She has a PhD in Philosophy (Political Theory) from Saint Joseph University of Beirut and she is frequently published in the domains of philosophy and literature. As a child, Dr. Malaeb witnessed and survived the Lebanese Civil War, an experience that she considers to have had a major effect on her life as an adult. Her contribution in the book is a series of short stories that reflect a form of ontological agony and despair shared by all Lebanese people alike. The characters and events of the stories are based on real-life givens; the details, however, are drawn from the author's imagination.

When one reads such a title in a book dedicated to Beirut in the year 2020, specifically, on the 4th of August of this aforementioned year, one would definitely wonder what is so fortunate about the timing? Why would the timing be described with such an uplifting term, one would wonder, especially considering all that had happened in Beirut in that specific schoolyard bully of a year?

However, after checking the stories below, one will reckon that the word fortunate is deployed in the title to reflect meanings of despair, frustration, loss of control, insecurity and helplessness more so than what the actual meaning of the word usually reflects. The reader will come to the realization that we, the Lebanese people, who are yet living still, are only so because of some haphazard fortunate timings. One will learn as well, that this part of the planet has set the standards significantly low for the word fortunate. Where I come from, considering oneself fortunate does not at all involve matching numbers on a lottery card, neither does it necessarily require a phone call with a formal acceptance letter to the university of one's dreams on the other end of the line. The word has nothing to do with acquiring one's dream house, nor the car of their imagination. In our part of the world, the word fortunate has come to comprise only the lowest and most disheartening connotations. Only the barest basic human needs for survival are covered with none of the well-being!

The below stories tell of how, on the fourth of August of the year 2020, some people—my family included—managed to escape their doomed death only by virtue of fortunate timings. And stories of how others were not as fortunate to escape.

So, I will start with my own story.

My story

Our plane landed on Beirut Airport runway. As usual, my eyes were wet. Maybe this was the hundredth time this plane took us on this same trip, for we had been abroad more times than my three kids could ever remember. Once a year, at around the same time, we took this same trip back home: back to our roots, back to where the trees are greener and the sky is clearer. In every trip back home, every time (and I really mean every time!), once the hostess announced the gradual descent of the airplane towards the airport and informed passengers of the outside temperature in Beirut, I'd look out to see the mountains that guard this little country of ours, and my eyes would always tear up. I never get to see the mountains clearly from the airplane. Their view is always hazy and blurred by tears. Be it on arrival or on departure, I always throw a glance at the mountains, but they are never clear in my eyes.

That time, July 2020, was a trip like all others before it. Or so I thought.

Detained and postponed by several PCR tests, travel-permits and return-permits, we made it. We made the yearly trip back to the place we call home, to our origins, to spend the summer.

While drinking my coffee on the terrace viewing the Bekaa Valley, I remembered someone asking me before I came for the summer, "You really want to go to Lebanon this summer?" The person wondered, "Are you crazy? There is nothing to do there this summer! The situation is disastrous!" And I remembered answering, "I never go to Lebanon to 'do things'! I go there to feel home."

At that moment, looking at the valley and enjoying the safety of the mountains' embrace, I thought to myself, if this person could see what I see now, he would understand why I am here. I looked again to better saturate my eyes with the beauty of the scenery, but I could not see clearly. My eyes were watering; this time, the tears were not sentimental for

seeing a long missed view of home, but caused by the summer wind. Our village is famous for that strong summer wind. Before the invention of air-conditioning, or even electricity, this same village used to be a seasonal destination for many Lebanese families escaping the heat of the city. The wind was playing with my hair, tackling my clothes, howling in my ears and squinting my eyes with tears.

How peaceful...

A couple of days before Tuesday the fourth of August, I gathered the kids to tell them that we will be spending the day in Beirut on Tuesday. We will be leaving the house shortly after lunch; we will stroll a little bit in Downtown, maybe a little break on Manara, and then we will dine in a restaurant that looks upon... guess what... the Port. "Your father and I had dinner there last winter break and it has the best food you will ever taste! Lebanese food with a twist!" I told them.

This was our plan.

Only one day before Tuesday the fourth, I was fortunate enough to receive a phone call. A phone call that, later I would come to realize, had saved our lives. "We are planning to go over to your place on Tuesday," my aunt said on the phone. "Around the afternoon," she specified. I was silent for a few seconds, then, I replied, "Can you make it on Wednesday instead? I promised the kids to go to Beirut on Tuesday."

"No," she answered. Her son, my cousin, who would be driving her, was occupied for the entire week. Thankfully, his only free day was that doomed Tuesday, the fourth of August.

"Should we make it next week?" she asked.

"No, no, we'll go to Beirut on Wednesday. I have nothing on Wednesday. So, deal! See you on Tuesday then."

We woke up on Wednesday and there was no Beirut! Most of the city was wiped out!

This is how fortunate we were: saved by a simple phone call.

Had my cousin been busy on Tuesday, we would have been in the midst of the explosion that day at around 6pm. We would have been dining in a restaurant that does not exist anymore; it was wiped out by the blast. Had I agreed to postpone the visit till the week after, or had my Aunt decided to drive herself to my house—because she usually does drive—and come see us on Wednesday instead of Tuesday, we would have been ashes by now!

Yes, we were indeed saved by **"fortunate timings"**.

The Story of Amal

Friday, the 7th of August: in a small, impoverished and extremely tidy house in the suburbs of Beirut, sat Marie on the couch surrounded by men, women, and even kids of the entire neighborhood. Some of the people around her were relatives, others were friends and some others were just neighbors and acquaintances who came to show sympathy and support for the yet unknown destiny of Amal, Marie's youngest son. In the Lebanese society, showing support in times of need is a cultural tradition that is held in high regard.

More than thirty people were crammed into that tiny house, not giving any attention to social distancing, viruses or pandemics. Evidently, when death comes in the form of a sudden massive explosion that changes the colors of the skies, the smell of the air and the topography of the earth, it takes one's attention away from the only small probability of death that a tiny virus might bring.

So, Marie was sitting in her house—dressed colorfully—as was everybody there. Marie had refused to dress in black, and refused anyone coming into the house to be dressed in the color of death. "Amal is alive! He is alive!" she said. "His phone rang twice the day before yesterday," she kept saying, while holding her phone and constantly looking at the screen.

Marie's fingers were all scratched, her palms scraped and cut. Her arms had bruises and the small part of her knees that showed from the navy blue skirt only when she sat down, had dark blue bruises covering them. Those scars would go in a week or two, but I am afraid that what brought them would scar Marie's entire existence forever.

Marie had been searching for Amal herself for two days, under the rubbles, or at least under the rubbles that they allowed her to access. The port area was closed except for professional troops and police forces. But, she thought to herself, maybe Amal had left the port to get some coffee somewhere nearby. 6 p.m. is his coffee time! She knew it!

So there she was, running like a mad person, shouting out his name, from one hill of debris to another. From one ghostly structure to another. "AMAL! AMAL!" she screamed. Tony, her eldest son, was with her. He was there watching her vent out her pain and scream off her agony from the top of her lungs, shouting, "AMAL! AMAL!"

Two days and two nights of shouting for Amal made her tumble down and collapse on the third day.

Amal's late father chose his name. Amal was conceived in 2000, the year when Marie and her husband had decided to repatriate back to Lebanon. When the boy was born, his father decided to name him Amal, which means hope in Arabic. "This is the hope for a new life in Lebanon," he said back then.

Marie opened her eyes on the seventh of August to find herself at home, in her bed. Her voice lost. Her tears dried. Her arms were very heavy! She knew they had given her some sedatives. But despite everything, she managed to get out of bed, dress colorfully and walk out of the bedroom.

All she could do now was sit there, hold the phone and wait for Tony's call. He was still at the Port searching for Amal.

A while later, in the afternoon of that same day, Marie's phone rang.

"Hello, Mama?"

Marie did not reply.

"Thank God ya Mama, we found his body! At least we have a body to pray for and bury, Mama." Tony continued, "Let's be grateful for that, at least... Mama, other people had only remains, or did not even find a body...." At this point Marie dropped the phone and screamed. But her voice did not come out.

Marie wore all black ever since.

Baby Heba

The month of August was part of Jowan's maternity leave. She had just given birth to the long awaited child. Jowan and Feras had been married for nine years, most of which they had been trying to conceive, but with no luck. After several failed and extremely expensive IVF treatments, they had decided to give up on the idea of having a child. Nothing was physiologically wrong, doctors would always say. But the couple never knew why they could not conceive.

Jowan had been on all sorts of fertility and hormonal pills. So visiting the gynecologist on a monthly basis was a kind of duty that she owed her body for as long as she could remember of her life as a married woman.

But there was this particular visit that was unlike any other.

The doctor had asked her for a regular blood test for that particular visit. And then a couple of days after she had run the tests, the doctor called her himself and asked that she visits the clinic to deposit another blood sample.

"Why? Is everything ok?" she asked him.

"Yes, sure, just some additional hormonal tests that I had forgotten to add on your papers for the lab," the doctor answered.

So she went again and deposited yet another blood sample.

On the day of the appointment, the doctor was supposed to, as usual, discuss the results with her.

She entered the office and saw her file in front of him on the desk.

"Is everything okay Doctor? Why did I have to repeat the blood test?" Jowan asked.
"Because I wanted to make sure, and now I am!" the doctor said with an inexplicable smile. Not allowing Jowan time to ask or say anything he continued, "Jowan, congratulations! You are.....pregnant!"

Several months after that appointment, Heba was born: a perfect, healthy and glorious baby. They named her Heba—the gift, the jewel of the family, the source of life to her parents.

On August fourth around 6 p.m., baby Heba was napping in the living room next to Jowan. Heba was barely a couple of weeks old and Jowan was still struggling to pick up a routine for her and the baby.

There they were, the two of them, in that apartment in Beirut—Jowan was watching TV killing time before her husband came home, and Heba napping next to her in the stroller.

Beams of dusk's sunlight crept through the balcony's gigantic glass door that faced the Port. Jowan decided to move the stroller closer to the glass door so that the baby would get some vitamin D from the sun. She had read that the afternoon sun was the best for babies.

She moved the stroller with Heba sleeping in it.

When next to the window, baby Heba screamed with a high pitch.

"Aw, I shouldn't have moved her, I woke her up," Jowan thought.

She pushed the stroller back and forth, but the baby kept crying. Jowan finally held the baby in her arms and rocked her a little, but Heba kept crying.

"Maybe she needs to be changed," Jowan thought and, at that moment, she left the living room to go to change Heba.

While still in the corridor heading to the bedroom, a strong blast swept them both off the ground. Jowan was thrown to the end of the corridor. She opened her eyes, everything was almost dark. The lights to the house were all out. The beams of dusk, that had crept into the house seconds before, were all gone. Smoke, dust, and darkness filled the entire apartment. She could feel Heba was there, still crying in her arms.
"Thank God!" Jowan thought.

The stroller however, that same stroller in which baby Heba was sleeping seconds before the blast, was found on the street next to the building facing the Port.

Tell me about fortunate timings!

The Kind Person with Beautiful Eyes

In 1982, in the middle of the Lebanese Civil War, Ahmad was born to the newlyweds Salwa and Jihad. Jihad was a sergeant in the Lebanese army at that time.

When Salwa was pregnant with Ahmad, she would always meditate on Jihad's hazel eyes, especially when he entered the house back from the service, while he still had on the army uniform. The color of the uniform, she thought, best captured the greenish hint in Jihad's eyes. Every time Salwa would share this with Jihad, he'd cast a virile masculine smile at her, diverting the topic. Beauty was not something that a man would necessarily take pride in within the Lebanese society of that time.

Jihad and Salwa were madly in love.

That cruel civil war did not end, however, before taking Jihad away from his family. There was one day, when Ahmad was less than a year old, that Jihad returned home, but his hazel eyes were shut forever.

A while later, those same hazel eyes that Salwa had adored, opened again. This time on Ahmad's face.

"Luckily, you have your father's eyes," Salwa would always tell Ahmad.

Growing up in a poor family, and barely having access to proper education, Ahmad considered himself extremely fortunate to secure a job at the Port a few years before the

explosion. He was happy with his work there. He started off as a mere carrier loading and unloading goods on and off ships, then a while after his appointment, he was promoted to a better position.

At around 4 p.m. on that day, the fourth of August, Ahmad was in the locker room taking off the uniform that had the company's logo on its left side and putting an end to a long and hard day.

"Ahmad, the shipment is here," his supervisor called to him from the door, "Gather your men and tell them they have to stay late, and will be paid for the overtime."

"How much is the payment this time?" asked Ahmad.

"Five thousand liras," the man replied, tilting his head and shrugging his shoulders.

"Weren't we promised a raise for the overtime work?"

"Listen, Ahmad, no one is forcing anyone to stay overtime. If you and your crew do not want to work, I can manage! But we're not paying more than that today," Ahmad looked at his wallet.

"Better than nothing," he thought. So he stayed for the five thousand liras.

Upon receiving the news of an explosion at the Port, Salwa rushed to Beirut.

She was leaping madly from one hospital to another, from one hell to another, looking for Ahmad. Thousands of people roamed the streets on that unforgiving day. Thousands of different faces, yet they all looked the same. They all had the same lost and terrified look. And Salwa was just another face, and had just another look.

The ghostly city looked like a gruesome ancient graveyard, all greyed. Spots, splashes and puddles of dark red randomly tinted its streets here and there. The buildings stood naked and shy. The air smelled of dust, chemicals, and gunpowder.

Yes, Beirut looked like a graveyard on that day, but it surely did not share the quiet serenity of one. Noises of all kinds came from every direction: sirens of ambulances, fire trucks, civil defense units, army trucks and police cars. The screams of people, however, were the most dreadful. Those screams filled the streets of the city on that day. They were the kind of screams that, once heard, would haunt the soul, the mind and the dreams forever. Shrieks of agony, of pain, of grief, of loss and being lost filled the streets of that ancient city. Screams and shouts calling out names of beloved ones. Cries and howls that pierced the ears and chilled the heart.

This is how hell must sound like!

All this however, did not stop anyone from looking. Despite being lost and terrified, they were all looking. No one stopped.

Salwa was looking as well.

On the second day, after checking all rooms, all manifests of the injured and the missing ones, Salwa decided to settle at the doors of the hospital that was closest to the Port where Ahmad was supposed to have been at the time of the blast. She sat on a bench facing the hospital, watching the rescue vans coming and going. She was not allowed to enter the hospital anymore, "Your son is not here, ma'am," she was told. "Please, make space for others."

So she sat on that bench. Every time she'd see a person with a uniform of any kind, she'd ask them if they had seen her son, Ahmad. But no one had.

A man from the Security Forces, who had been in the same spot the entire day, saw Salwa. He'd noticed her for hours and seen her desperation. He approached, put his hand on her shoulder and said:

"I think you should check the morgues, Auntie."

"No!" Salwa replied, fixing her wet eyes onto his. "I do not dare," she said in a cutting voice.

"I will go in and check for you. Tell me, how does your son look like, Auntie?"

"My son.....My son is a very kind person; he is a very kind person, with beautiful hazel eyes....," Salwa screamed.

This is us, the Lebanese people!

The above are a few stories that reflect but a dainty glimpse of what happened to us on that day. Each and every Lebanese house and each and every family have a story to tell: a story of fortunate or unfortunate timings. Be that as it may, our life is always hanging by a thread.

We, the Lebanese people, have always been and will always be prone to death each and every day. We live side by side to death.

In my country, death comes to us in all forms and incarnates all shapes. Death comes to us in the form of war, negligence, pollution, civil disobedience and/or in the form of collateral damage. And, of course, not to forget, death can also come in the form of corruption.

On the fourth of August, corruption grew to staggering levels that were more than what the heart of our beloved Beirut could contain anymore. So corruption eventually burst in the form of a colossal explosion that shook the earth underneath us and shredded our world into non-amendable bits and pieces.

Those who died, may they rest in peace and those who are still living, are so only by virtue of some haphazard **fortunate timings!**

WHAT
IS THE FATE
OF OUR
REVOLUTION?

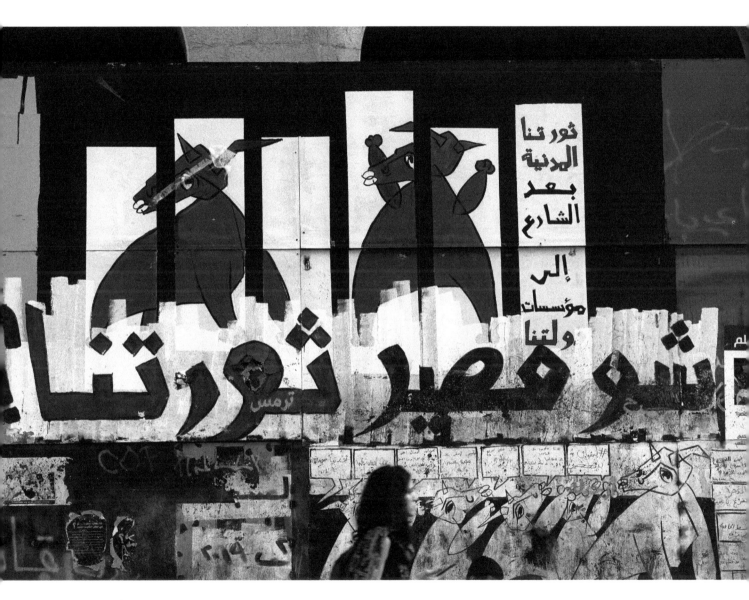

And Now What: Less than a month after the October 17 uprising, artists asked themselves and the public about the revolution's fate.

JOELLE SFEIR

Insha' Allah

Joelle Sfeir draws from her life when writing a short story, a book, an article, a blog or only impressions. Her publications are as various as her experiences in life. What she writes reflects who she is and what she thinks. With a university degree in geography, years of work in the communication and teaching sectors, experiences with travelers as a tour operator and a guide animator, and living between Lebanon and Canada, Joelle gets inspired and writes in different forms. From building websites from scratch, to translating documents and creating content for international organizations such as the UN, Joelle has a way of writing with a graceful pen and expresses things beyond simple words. In many articles, for example in the blog RedLipsHighHeels.com, Joelle gives a special place to empower women and portray their situation in the Middle East, and especially in Lebanon. Her short story "L'arbre Rouge" was published in a collection of short stories in Geneva in 2004. The book she co-wrote, *Hyphen Islam Christianity*, won the Special Mention at the 30th France-Lebanon Awards organized by the Association des Écrivains de Langue Française (ADELF) in 2010.

Uncertainty is the new certainty. Living in Lebanon, we thought we mastered uncertainty. We have a saying: God Willing, Inshallah. For any appointment, friendly or professional, urgent or not, this sentence is added. I'll see you for coffee tomorrow, God willing.

When I first arrived in Lebanon, that sentence got on my nerves. It still does actually. More than I can say. God must will! Because if not, it means that I can show up for a said meeting and the other party is at liberty to not show up. It gives every single appointment or meeting/booking a tint of uncertainty and... well ... *perhaps-ness.*

This ever-present uncertainty was generated by war and car bombings and many events of civil unrest over the past decades. They were nevertheless sporadic—the events of the past couple of decades I mean, which allowed us to continue operating within the confines of a certain certainty. Things were somewhat certain. One might not be certain they would be in a specific spot one year from now, but people still booked wedding venues and trips and made commitments a few months ahead of time. Within this frame of guarantee, things were OK. People went about their business. In Lebanon.

While in the West, certainty was oh so strong. People made travel reservations three years in advance. A shocking reality for us Lebanese, who plan a maximum of six months in advance. But hey, to each their own.

Things happened, we took everything for granted, we complained and nagged and got frustrated about small hitches... But overall, certainty was the norm in an uncertain country, where things could go crazy any second; a second that could show up the day after tomorrow.

I was so happy of the very relative certainty in which I lived for most of my life. The possibility that one never knows what might happen was always there, in the back of my mind, just because I am Lebanese. Even living in Canada, while driving, having the assurance that EVERYONE stops at a red light, I would still make sure no one was coming at a crossroad. Who knows?

Who knows? The underlying question. Always. Who knows who killed JFK? Who knows what made the port explode on August 4? Who knows what tomorrow will bring? And this question has made it more or less possible to stomach the tax increases, the wild fires, the revolution, followed by the economic crash, followed by the explosion, followed by the spiraling economy... We accepted it because our tolerance threshold had been raised very slowly over the years, one event at a time. The thing is with tolerance, if you don't react the first time around, it becomes easier to take the next blow, and then the next, and then the next...

Until the chain of events led us to 2019, then 2020, and slowly into 2021.

Uncertainty took on a whole new meaning with things changing every minute. We never thought some words, situations, and moments would become so benign, so real, so surreal, so shared by everyone. Lockdown. No more withdrawals possible. The bank is not giving me my money. Tear gas. Ammonium nitrate. Suddenly, we are all geeks. And economists. And lost. And confused. And uncertain.

People—we, us—live in fear. Walking our streets doesn't feel safe anymore. Writing an opinion online isn't safe. Meeting friends isn't safe. Uncertainty has surrounded us. Fear seems to be the only emotion that is keeping us alive lately. Fear of Covid-19, of contamination, of online censorship, of racism, of the lockdown, of being poor, of being hungry, of not finding our favorite brand at the supermarket, of losing our job, of not being able to pay the kids' tuition fees, of losing our children to a car accident, of car bombs, or port explosions... The stress of it is unbearable. The uncertainty of it is almost romantic.

Living in Lebanon for the past seven years has undoubtedly made me realize that we have so much to be grateful for. It has made me realize how privileged I was. I had access to a good network; I was brought up to be an independent free-thinking woman, free of social constraints and pressure. That is a blessing. I thank my parents every day.

But it has also made me realize how fickle it all is. How solid we are on the outside. And how fragile on the inside. Unless it is the other way around. I don't know anymore.

We are strong enough to live in a country that doesn't give a shit about us. We are strong enough to deal with the economic hardship and the patriarchal society. Animal rescuers are heroic to deal with ignorance and cruelty; human rights activist are miracle workers facing ignorance and discrimination day in and day out. Social and political activists are wonderful people, facing an archaic institution. There are so many people who deserve praise and medals and golden cups and ribbons and applause and standing ovations and crowns in this country that I am continually amazed.

And yet, in spite of it all, until now, the system remains unchanged. I would venture to say it is one of the only three certainties of life: taxes, death … and our ruling class. Ironic.

Living in Lebanon, we took uncertainty to a whole new level. Uncertainty became the impossibility to know what tomorrow is about, or even a synonym to the unbelievable amount of resources and imagination we develop every minute of every day to solve stupid problems that don't exist anywhere else in the world. Well, at least not in most countries. How to manage to pay the rent, and the bills, and the employees (for those who have any) and have food in the fridge, and pay the vet bills or the school fees—with a ridiculous limit imposed by the banks? How to send money abroad (any good solution honestly deserves a Nobel prize)? How to find medicine for a diabetic partner? How to find oxygen for a sick sibling? How to support people in worse situations? And yet, we continue to help those in worse situations, create Facebook groups and pages to help each other—and people we don't know. All you have to do is write a post and prove you need help with something. We manage to give donations, share excess food, send blankets, help find medicine or much needed resources, networking to see who is coming from abroad to bring necessities…

The list of questions, or uncertainties, goes on and on.

How to keep a small business afloat? How to pay the bills when your income is worth zilch? How to pay for your children's tuition when you lost your job? How to survive winter when you lost your home in the explosion? How to face the cold when you are condemned to live in a tent in a country that wants you out? How to move for work when you cannot afford gas? How to continue when you lost your money because of the economic crash, then your home because of the blast, then your child because of a car accident? How do you continue when you lose your face because of the blast? How do you continue when forty-five years of savings have been flushed down the drain and you find yourself deprived of everything you have worked for?

And how dare you complain when everyone around you is facing this and you are OK? When you managed to somehow be OK, when you weren't in Beirut on August 4, when you lived in confinement in a mountain house with a huge garden, when you managed to eat and drink and pay your rent and your bills, how dare you complain?

How dare you cry because Beirut was blown up, because someone you fell in friendship with lost half of her face, because your cousin and friends and work partners lost their homes, because friends lost their savings, because everyone lost their happiness and joy? How dare you feel pain and sorrow and rage and unimaginable contempt towards those who continue doing this to us when other friends left the country promising never to come back—just like I did all those years ago? How dare you hope they will come back—simply because I came back? How dare you be jealous of those who found a job abroad while you are staying here—even if by choice?

How do you dare express anything at all when you face the uncertainty of tomorrow, the bank constraints, the economic hardship—but with your health intact and your body unscathed?

How dare you talk about the situation here with a smile plastered on your face because you don't want to sound like you are complaining? After all, the entire world is paying

for failed and crappy health policies that have made it impossible to face the onslaught of the pandemic.

How dare you think that we have had it tougher than most—when you are in a zoom meeting, circulating on international networks, hoping that work will come back sooner than anyone thinks?

How dare you feel any negative emotion when you know life will never be the same again—ever—but that you seem to have the mental strength to remain sane when all else is crumbling, just because you are OK—physically and financially? How do you even imagine you might feel down, or, God forbid (I also dislike this statement, though I use it a lot. Go figure!), depressed, because of the bleak uncertainty of life in Lebanon in 2020 and forward, when you have an escape route (a foreign passport), a family that can help you, and the resources to work on different projects?

Uncertainty has filled everyone's brain. And the certainty of not being allowed to complain when we know we are better off than so many people has made every negative emotion a taboo. And positive ones too. Who gloats when the country is on fire? Who gloats when everyone is lost, in pain and feels a sadness beyond anyone's explanation?

This is what living in Lebanon does to you. You say, "Al Hamdou Lil Lah" (a bit like you'd use "God willing" or "God forbid") as much as you say "Fuck!" You say, "I am okay," as often as you think, "how am I going to survive this day?" You hate the country that makes you so miserable, that offers no guarantees, that offers no future prospect, no hope of change. This is what a country that is chipped away by militias, ruled by criminals, and governed by greed and ignorance and patriarchy and sexism and racism and all sorts of "isms" does to your sanity and your brain.

And yet. We are still here, doing what we do best: facing the uncertainty, looking at it and laughing in its face. Ha! You think we don't know what tomorrow holds? Fine! We are still

going to make plans and change them at the last minute to do other plans! You think your hate and ignorance and stupidity and cruelty will stop us? Well, watch us! Watch us as we help the hurt animals, migrant workers, and beaten women, and refugees, and children, and patients... Watch us as we defy all odds and make this shit happen!

Watch us as we live today and have fun, and are strong and help each other and enjoy the sun and cozy up inside with family while the cold passes.

Watch us as we continue to attend online conferences, and webinars, and meetings, and Skype calls with family abroad, just because.

Watch us cook meghli (a rice-based dessert served when a newborn comes into the world) when a relative has a child in Canada and we eat it alone, with a smile of joy and tears running down our face.

We love this land that inhabits us. We have a strong rooted love for this country that drives us nuts. We love it so much that we are always amazed by all that it holds, all that it encompasses, all that remains uncovered in it.

Everyday something new, never knowing what's going to unfold. Or be uncovered. Or be unearthed. Or will come to pass. This uncertainty has made us who we are. It has made us appreciate the treasures of this land much more. It has made our imagination more vivid, our dreams more daring, and awakened our senses.

We are legion.

And we will remain until all else subsides.

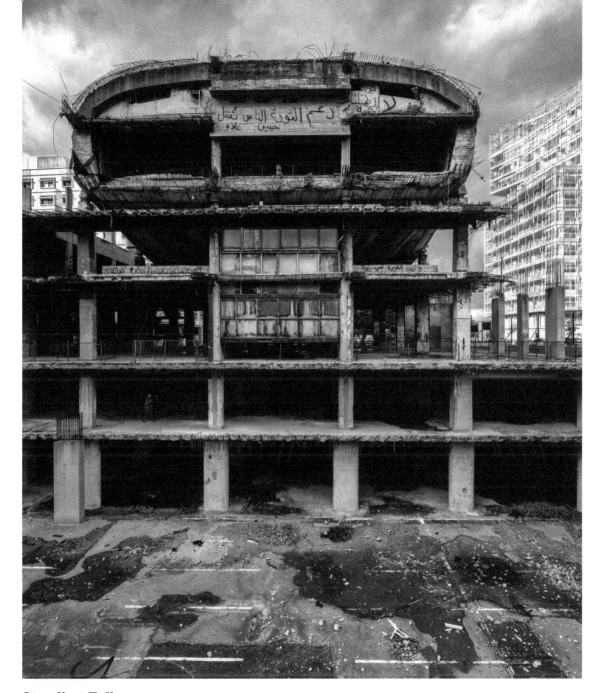

Standing Tall: The Egg, a cinema constructed in 1965 as part of the unfinished Beirut City Center complex in Martyrs Square. This view was possible due to the fact that the usual barricade erected by the government was torn down by protesters at the start of the uprising of October 17, giving a glimpse of hope to the Lebanese people that they could reclaim their city in one way or another.

FATEN YAACOUB

Bayrut

Faten Yaacoub works as a freelance media producer. She has worked as a lead researcher at Middle East Broadcasting Center. She has been involved with Potential SF's project on Waldorf education in the Middle East. She taught at the Lebanese American University, the American University of Beirut, and the Lebanese International University. Her background in academia is key to her understanding of different cultures and meeting new challenges in her current career. Faten's study of Comparative Literature, in addition to her native Arabic, endows a comprehensive dimension to her research, translation, and media production skills.

Wells of weeping,

That's what evil times

Have turned you into.

You used to quench

Our thirst for beauty,

Our love for life.

Look at you now:

You look tired,

You can't even dust off the ashes,

Retiring into wells of blood

And the scent of rot;

You wear your smoke

Kohl for your teary eyes;

You hide your heart

From the monsters of the dark

And cover your face

With a sad smile.

We parade for your awakening.

We beat our drums.

We light the torch

And clear the way.

Our Bayrut, our Beirut:

Come back for us;

Wake up for us;

Gather your ashes

And rise above your wounds.

Your Phoenix is immortal

And that's what they don't know.

But we have faith in you,

In your alleys and corners,

Your windows and sea,

Your streets and late lights.

Cleanse your doors

With the wells of purity

And break down the walls of fear;

Chain back the thugs of evil

And bury deep the arms of hell.

You were born a lady,

And a lady you shall always be

Still Standing: A dilapidated chimney from Beirut's Pink House known as "La Maison Rose" in Ain Mreisseh, near the Raouche area.

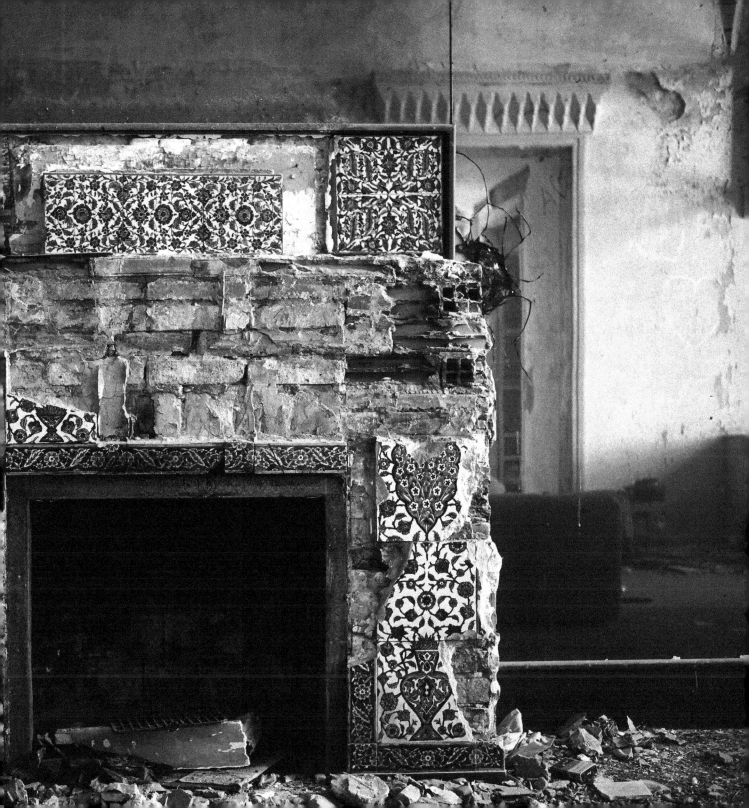

REINE ABBAS

With great change comes great responsibility

Reine Abbas has more than 17 years in the gaming industry, higher education, and the arts. She is the CEO and Co-Founder of Wixel Studios and also the CEO and founder of Spica Tech. Abbas' work has been recognized around the world. Awards she's received for her work include the WIT Women in Technology Award in 2010, the WOW award for artistic expressions in 2013 at the 6th New Arab Woman Forum, the winner of MIT Enterprise Forum Pan Arab Region competition in 2017, and the Mena Region winner in the Cartier Women's Initiative Awards of 2019. Abbas was listed by Inc.com's as one of the world's five most powerful women in gaming in 2013, and as one of The World's 100 Most Powerful Arab Women in both 2014 and 2015 as selected by ArabianBusiness.com. In 2019, she also won the Best Animation award at the ARFF Paris International Awards for her music video "Right Now". She was featured in Forbes 2019 and was a TEDx Beirut speaker in 2011

Founder & CEO, SPICA TECH S.A.L Spica Tech S.A.L
Co-Founder & CEO, WIXEL STUDIOS Wixel Studios

TEDx TALK
Cartier Women's Initiative Awards CIWA
Venture Beat VB
ArabAd The Element Of Initiative
Arabian Business The 100 most powerful arab women 2015
TheirWorld ORG Rewriting The Code
Brilliant Lebanese Awards BLA2018
Le Commerce Du Levant Artiste-engage-au-service-du-jeu-video
FORBES Japan Forbes Japan 2019
Wamda One of the five most powerful women in gaming
The961 One of the World's Most Powerful Arab Women

I remember the moment the Beirut port blast happened and how my body was thrown and hit the door. I cannot forget the sound. I cannot forget the fact that I couldn't see anything for minutes. I almost died. I survived by chance. The first thing that came into my mind knowing that I wasn't personally injured is how to get to the nearest hospital and donate blood because it was something I had done in times of crises.

Every time I look at old pictures of the office, I remember how lucky I was to survive the blast, and how lucky my colleagues were because they weren't there. I only thought about my kids; I knew they were safe at home but I couldn't help thinking about what would have happened to them if I was injured or if they were with me at the office. I survived many wars in my childhood, but this time, the fear was different. We are adults: we are much more aware of the danger, and today, our life is not ours anymore.

Lebanon has always been a challenge to all artists: painters, illustrators, animators and others. Until the present day, the animation industry lacked experience. There are not enough experienced animators or producers in the country and the region to produce influential animated movies. As for visual artists, even if hundreds of students are graduating from all disciplines and universities, the country's market is too small to cater to the growing number of needs and talents, and there are no investors in this field. We have a lot of art galleries, but not enough collectors and buyers.

It all changed with the October 17th revolution and the impact it had on the art scene in Lebanon. When the revolution started in 2019, many local artists and especially the young and emerging artists, finally had a cause to defend and the means to express themselves while serving this cause. Being an animation teacher in four universities, I knew for a fact that my students were stuck and had no self-confidence in their artwork. They had never worked in art illustration or published their work before. In that sense, the revolution, as an art scene per se, was the perfect place for them to express their feelings and emotions. Many Instagram pages were created in 2019 and 2020, publishing the work of established and emerging artists. In my opinion, it was a great therapy for all

the creative people in Lebanon, but right after the Beirut port blast, the art scene became less active. The explosion shocked us all. People became depressed and rushed back to their bubble. They lost hope for any change and they were back to square one in terms of expressing their emotions.

Now and more than ever, art should be used as therapy. It is the best way to express and deliver any message but nevertheless, the Lebanese youth still lack self-confidence in all disciplines. They tend to copy other international artists, because they consider them more experienced and talented. I believe it's all related to our education. So I use every opportunity to advise the youth, whether in my classes or as a public speaker and judge in competitions, to sustain their ideas without cloning others' work. They can definitely be inspired by others, but they should develop personal and original work. I tend to teach them how to gain more confidence and use their imagination to create their own art process and style.

Last but not least, we all know artists have a responsibility that is appealing to everyone. People immediately connect to art and share it. Therefore we, as artists, need to be more responsible about what we draw or write when we communicate with our audience. We shouldn't use art and make it a cheap way out; we should keep it at a high level. I am not talking about the style, but about the message we are putting out there for the public eye. It should translate everything that we cannot say in our everyday life.

We have amazing artists in Lebanon and in the region, who are expressing themselves in a very aggressive yet beautiful way, and they are contributing to making change. But with great change comes great responsibility, and artists have more responsibility than ever to act in ways that benefit society at large and directly advance social goals. In other words, their artworks should exemplify the promotion of social responsibility.

SILENCE IS A SECOND CRIME, ONLY YOUR ANGER AND YOUR LOUD VOICE
CAN EXPOSE THEM! #THEPEOPLE_PROSECUTE *(translation)*

OMAR SABBAGH

Extreme unction – Beirut at the end of its tether

Omar Sabbagh is a widely published poet, writer and critic. His first collection and his fourth collection are, respectively, *My Only Ever Oedipal Complaint* and *To The Middle of Love* (Cinnamon Press, 2010/17). His 5th collection, *But It Was An Important Failure*, was published with Cinnamon Press at the start of 2020. His Beirut novella, *Via Negativa: A Parable of Exile*, was published with Liquorice Fish Books in March 2016. Omar has also published prize-winning short fiction. A study of the oeuvre of Professor Fiona Sampson, *Reading Fiona Sampson: A Study in Contemporary Poetry and Poetics*, was published with Anthem Press in July 2020. His Dubai novella, *Minutes from the Miracle City* was published with Fairlight Books in July 2019. He has published scholarly essays on George Eliot, Ford Madox Ford, G.K. Chesterton, Henry Miller, Lawrence Durrell, Joseph Conrad, Lytton Strachey, T.S. Eliot, Basil Bunting, Hilaire Belloc, George Steiner, and others, as well as essays on contemporary poets. Many of these works are collated in, *To My Mind Or Kinbotes: Essays on Literature*, published with Whisk(e)y Tit in January 2021. He also has two books forthcoming, namely, *Morning Lit: Portals After Alia*, a book of poetry and prose forthcoming with Cinnamon Press, in Spring 2022; and *Y Knots*, a collection of short fiction. He holds a BA in PPE from Oxford; three MAs, all from the University of London, in English Literature, Creative Writing and Philosophy; and a PhD in English Literature from KCL. He was Visiting Assistant Professor of English and Creative Writing at the American University of Beirut (AUB), from 2011-2013. Presently, he teaches at the American University in Dubai (AUD), where he is Associate Professor of English.

For my parents, Mohamad and Maha Sabbagh
And for my daughter, Alia Sabbagh: may she come to know a newer nation

The 4th of August is famous for being the day, in 1914, when the First World War began. In modern Lebanese history, perhaps it will be marked as the day when a final straw broke the camel's back. This date—a mere incidental number on a calendar— showed the world (iconically in retrospect) visceral and gory detail. It showed that a century or more of progressive hopes, wielding rationalizing progresses of technique aimed to liberate Man from natural burdens, and attempting to free their movements according to their supposedly benign intentions, was now defunct—this date displayed an ending of a different sort for the denizens of Beirut, Lebanon: an ending wholly shorn of the better sense of an end, a goal, a purpose.

The more oaken idea was that with progresses in material civilization, Man would be freed in time and space to come to be in a position to accomplish more good, creative and constructive things. However, whether it's mustard gas in a world war, or a (mere) machine gun; a nuclear bomb, or a blast like that in Beirut in the late summer of 2020, it is clear to even a child that the fruit of our instrumental capacities are in no essential or necessary way linked or hooked-onto what is 'rational' let alone 'reasonable' in the more substantive sense. That I can email someone in Timbuktu and have my message read within seconds that far away, that I can transfer money to a needy relative from my phone and save loved ones from harm in a matter of seconds, too, provides absolutely no excuse for a dead or wounded human body caught in the wrong place and the wrong time at the time of an explosion of record proportions—whether it was a criminal act or a tragic result of gross negligence. The nitrate ammonium stored in that Beirut port, whatever its origin, was not lodged there as part of some innocent, natural occurrence; its very existence in concentrated form, let alone stocked as it was in a manmade warehouse, is the responsibility, ultimately, of someone or some group's set purposes, be they mercantile or otherwise. And all this is to say, that for all the finality of the horrible effects of the August 4th blast in Beirut, the blast was just more evidence of how fragile we, the contemporary human race, are as a civilization, vulnerable now just as much, if in very different ways, as from the blasts from the past, so to speak. That said, I'd rather have my identity stolen by some internet hacker than have a loved one wounded or killed in an explosion whose ripping, sundering waves score a city of such life

and charisma with the rough music of (yet another) catastrophe. There are gradations and degrees of tragic issues, that is to say, it's not a simplistic black-and-white affair; but when innocents have their lives torn open, and torn open in a time when their lives are already viscerally, violently torn, tragedy transmogrifies into something even more infernal and unspeakable.

Strangely, that afternoon, when the blast happened, I had just returned from the beach and was seated at my computer, as I am now, penning at the time some verse whose title, eerily, happened to be 'The Foundation.' It was cruddy verse, but when the first waves of the explosion rattled our third-floor apartment, and then, with the second wave, I saw shards of glass in awful geometric shapes falling in front of the window on my right, looking back at that title while the earth beneath me shook was, shall we say, no aid towards composure for a man like myself, already prone to the odd bout of paranoiac thinking. As it turned out, while glass windows of shops below and apartment windows of flats above ours proved shattered, we ourselves were left in a material sense unaffected. My wife and my one-year-old child, who were to return from the beach in a second shift back home, appeared home fifteen minutes later and the relief was staggering. We all sat in the den of our family apartment, watching the news. It was breaking news: breaking news. But for Beirut and for Lebanon, its newness was part of a recent pattern of decay, or decline and fall, that might make a cynic of even the most sensitive, compassionate or optimistic soul. When would the destruction, economic, physical, moral, psychological and spiritual—when would it stop? When would this city and this land, one of the cradles of human civilization, stride again in the robes of its fertility?

The Phoenicians, who were ancient inhabitants of the land of Lebanon, gifted us the alphabet, among other things, speaking to the sheer dynamism of the lands of the Levant in times of yore; but there are no words, or logoi, that may appositely and properly spell out or justify the realities of hurt and suffering now at hand in Beirut and by that token, Lebanon. That true disclaimer made, however, I want to wander a little in these few pages, discussing aspects of my own personal experience of Beirut: the experience of

the son of Lebanese parents who, born in London in 1981, to this date remains in some important respects a foreigner, however much the strings of his heart may be tugged. A foreigner, not only in terms of having grown up highly privileged and away from Lebanon, in London; but also, a foreigner to the true wounds, as experienced in the flesh of the Lebanese, then, or now. I need to make this disclaimer not only for the staple function of delimiting any claims to authority when reflecting on Beirut, but also because it will no doubt prove to color in substance the way I write about Beirut in what now follows.

*

Alighting, happily but unhappily, on the mildly punning phrase about the blast and the blasts from the past, let me set the scene. It must be 1986 or, say, 1987: Lebanon's civil war still in horrid motion. I, a five or six-year-old, am lying prone on my stomach on the lushly carpeted floor of the salon in our large mock-Georgian house in Wimbledon, London. My parents, sitting plum behind me in each of the respective corners perpendicular to each other, on the sofas which lined the farthest corner of that plush and comforting room (so warm in memory) are watching the news from Beirut, Lebanon. A mere child, I don't wholly follow what we happen to be watching, but to this day I have a visual mnemonic to hand: I see intense waves of awry, rolling greys on the screen of the television, the grey of a city like a wilderness of piled rubble; it is an image stuck in my head as though of some modernist, abstract sculpture. But what I am watching is of course no work of art; it is a heartbreaking devilment. I remember, too, the kinds of forlorn phrases that came uttered like soft, sad expletives from my parents' lips as they beheld the troubled destruction of their homeland. Years later, when more cognizant, I would be told that during the late seventies or early eighties, my parents and their fellow expat friends in London were wont to play Feyrouz songs on the LP player and, mildly tipsy with drink, weep together at the bereft state of what was for their generation—specifically the Paris of the Middle East—a country once so rose-tinted for them, busied by their hopeful youth, but a country now colored so frightfully with fey, occult chiaroscuro.

I grew up in London, very much with a British mindset, if always with a deeply Lebanese heart. To this day, I 'get-by', only, in speaking Lebanese, while being, staying, close to a null-point in relation to written and literary Arabic. But vicariously I suppose, via the conduit of my love for my parents, Lebanon and Beirut in particular are charged and invested in my imaginary with patriotic instincts or sentiments. I remember being a young Marxist at fifteen or sixteen and, when queried about this precocious fact by his friends, my father would reply that while I may have been a convinced communist, I was nonetheless 'a patriot.' It was a revelation: from that moment, my father's prioritizing, even if only incidentally, 'patriotism', disclosed to me his utmost wish for me. A highly tolerant and a highly liberal-minded man, a man with the kind of tender heart I have never seen equaled—it became clear for me that insofar as I loved my father, by that token I loved Lebanon. And this, despite, as I have already mentioned, the many ways, geographically, materially, linguistically and even psychologically, in which I was, and to this day remain, somewhat of a foreigner.

After completing my Bachelor's degree at Oxford, I went to Beirut for about six months, ostensibly to work on my 'Arabic'; but, naturally, as an extremely idle man, even at that young, auspicious age, I played hooky most of the time. Though I did begin to speak Lebanese more fluently and for the first time, I absented myself from the paid-for classes and improved my classical or literary Arabic by perhaps one or two percent, and that's it. The next signifying period in my Beirut-orientated life was in 2011, when, having completed my PhD in English literature at KCL, I got my first job as a Visiting Assistant Professor of English Literature and Creative Writing at the same AUB where my parents had met back in the sixties. Apart from the felicities of some of my lectures or classes, the years 2011-2013 which I spent full-time in Beirut, stay with me in a kind of cloudy, fogged fuzz. The vast majority of my experience was not only just in Beirut, but mainly, moreover, in that enchantingly rugged part of West Beirut that is Hamra. And it was the experience in effect of guzzling the equivalent of half a bottle of vodka each night after work or on the weekends in one of the many bars literally just around the corner from my flat in Sadat street. Nonetheless, they were, relatively-speaking, good times. And since

leaving-off living in Beirut, full-time, in 2013, I have of course visited over holiday breaks at Christmas or Summer. All that said, though, from the time of October 2019, when the 'revolution' was incrementally and then exponentially relayed on our news channels, through to the following summer of the camel-breaking blast at that Beirut port, Lebanon and in particular Beirut has been with such sad force newly-minted as a central concern in my mind, imagination and heart.

*

I am no longer an aficionado of contemporary politics or current events, Lebanese or otherwise. Mainly, if I'm honest with myself, because I'm lazy, and am obtuse enough to believe myself when I tell myself that my intellectual concerns are with epochs not days. This pertaining laziness, it goes without saying, this supposedly apolitical position is itself a political product: I can, clearly, afford to avoid politics. While politics is of urgent concern to most of the world's population, turning apolitical is a kind of self-indictment, picketing at myself as I plant or graze in what Voltaire would call, candidly, my 'private garden.'

However, when the 'revolution' began its upsurge I became, but only comparatively-speaking, alert again. It was clear to me that a dam had been broken in the modern history of Lebanon. We were, it seemed, entering a new and demarcated era. And for all the fallow fruit since of this grass-rooted movement, this revolutionary upsurging movement must be a good thing, even if only in the longer term. However, as Keynes famously quipped, in the long term, well, 'we're all dead.' And this is the problem, I think anyway: yes, the people have spoken; yes, a dam has been broken; yes, things politically will never be the same; yes, yes, yes: all fine and dandy. But in the meantime, in the cruel times intervening between now and Lebanon's deliverance into a newly-lighted dawn, people who are not in any way as privileged as myself, will have to suffer, economically and spiritually. It is of course an age-old conundrum: things will, as they have to, get worse in order to get better. But not everyone is a hero, or martyr, or wants

to be one: and that, quite rightly so. And then, the pursuant, ruinous blast in summer 2020 only exacerbated the Lebanese doldrums. In keeping with this taut problematic, if you like, here is a scenic image from Christmas 2019.

I am sitting in the den of our quite luxurious apartment in Verdun, Beirut, watching the news with a vague eye. Suddenly, I hear a high-pitched exclamation and the small ringing clapping of hands from my parents' master bedroom nearby, round the corner. My father rushes into the den and shouts at my mother, who is sitting next to me, busied by her daily crossword: 'Did you see that, did you hear that??!' Apparently, one of the members of the audience in a popular and influential talk-show on one of the major Lebanese channels had just made a (revolutionary) comment which to my father's seasoned, politicized eye was right on the money. I can't remember now what the content that so excited and pleased my father was, but I do remember the distinct, vivid impression of his newly invigorated excitement at the revolutionary movement in Beirut and Lebanon. It was like he was twenty-five again!

But then, the waning of the revolutionary effects; and then: the hell-bound blast in summer 2020. And then, the return of a certain reluctant cynicism. When I ask my father today about his view on the current situation in Lebanon, his reply in idiomatic Arabic always is: 'Small children, small children: they're like spoiled little children!' Meaning, that the politicians have no vision or patriotism, blocking any progress for face-saving and perhaps more debilitatingly for personal power-saving reasons. They all, to his mind, place their advantageous positions of power, or indeed, their sly and wily positionings, miles and miles and miles ahead of any of the country's interests, moving forward. Spoilt children, kidding themselves, kidding us.

Of course (off course), in the individual, biographical sense, that is politics and politicians, almost by definition, anywhere, everywhere. But beggars can't be choosers. Beirut, Lebanon, a small and weakened country—even if peopled with some of the world's most dynamic and adaptive people—just can't afford politics in its staple,

almost-universal senses anymore. In fact, one might argue, paradoxically, that a truly self-interested politician, in, specifically, Lebanon's current state, would probably serve their personal and most selfish interests best by becoming an honest human all of a sudden! Because the sinking ship will take you down with it, inevitably, if you continue to allow it to sink. That, I suppose, is simple, factual, aquatic physics. Perhaps, if counter-intuitively, the foreboding ending in Beirut, Lebanon, may, by some strange but felicitous magic, turn about itself, and become once more a thing of true-billed ends, goals, purposes? Because Man, in any humanist dispensation, should be able to control matter: not matter, Man. And whether we mean this in, say, a Marxist sense, repudiating 'commodity fetishism', or indeed, in the sense that a warehouse full of prone ammonium nitrate should not be in a position, being mere inanimate chemicals, to determine the fates of the Lebanese—in whatever sense you choose, abstract or concrete: we owe it to ourselves to gather-up the reins and turn power into authority once more, and violence into flourishing solidarity. A dying nation can be brought back from the point of death: but the time left for the application of the oils of extreme unction is running out. In fact, the oil itself is running out.

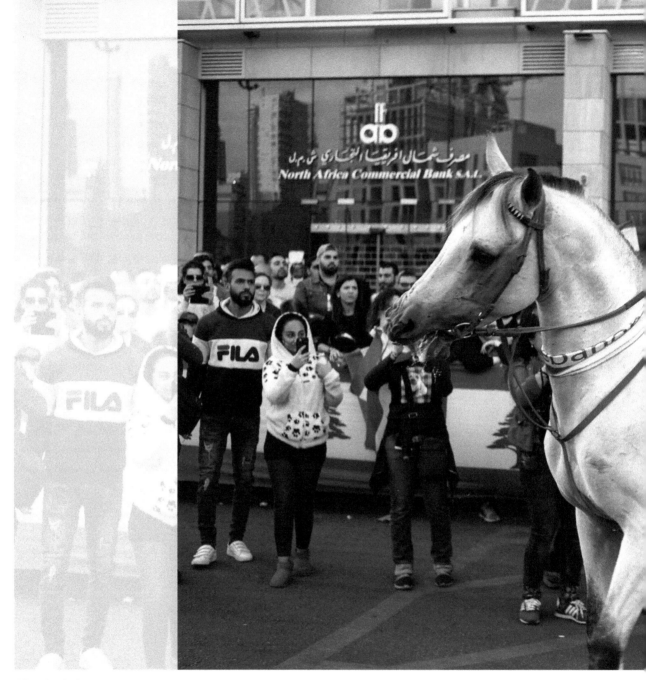

The Knight: A horseman riding his way through the crowd on Independence Day 2019, as part of the festivities organized for the first time by the people, not the government.

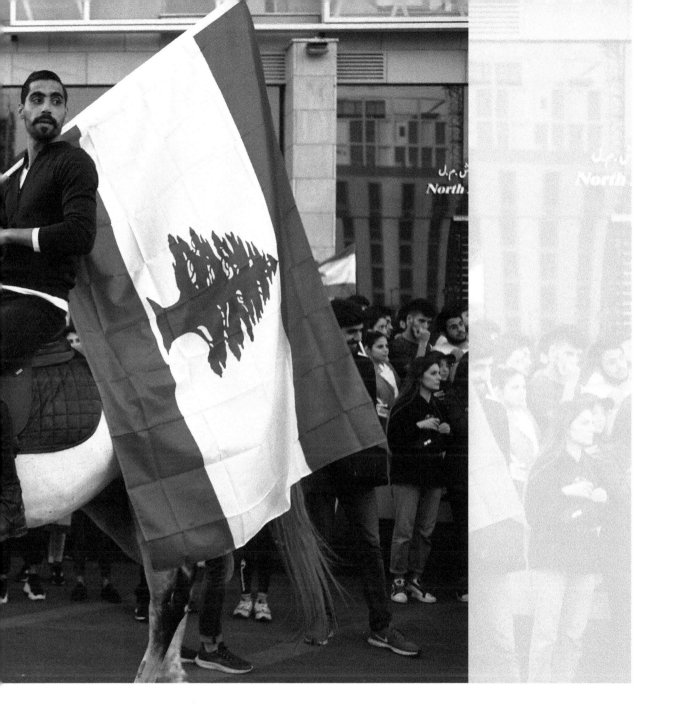

CLIFF MAKHOUL

Sunday afternoon at Martyrs' Square

Cliff Makhoul is a Beirut-based photographer. After his father taught him how to mount a lens on a camera body as a teenager, he fell in love with photography and in that moment, he knew it would play a big part in his life. After graduating with a BA in Photography from the Holy Spirit University of Kaslik in 2009, he started freelancing and experiencing photography through most of its facets. Makhoul has been the senior photographer for Beirut Jam Sessions since 2012, taking concert photographs of international and local artists. He has been senior laboratory assistant within the Photography Program at Notre Dame University-Louaizé (NDU) since 2013 and in 2018, he accepted the position as a part-time faculty for teaching photography. In 2019, his work was part of a publication about the October 17 Revolution. In 2020, he submitted his photograph 'Sunday Afternoon at Martyr's Square' as part of "October 17- Second edition", an exhibition curated by Janine Rubeiz Gallery. Currently, he is working on a personal project, documenting the town of Zouk Mosbeh.

During the first month of the October 17 Revolution, I went to the streets, camera in hand —almost on a daily basis—trying to capture the change that was unfolding right in front of me. The proactivity was as much about documenting what seemed to be a pivotal point in the history of the country, as it was about participating and being an active part of the change. On Sunday, November 17, 2019, a month after the 'Thawra' (revolution) had started, I headed towards downtown Beirut—Martyrs' Square specifically—as it was a central point in the uprising.

Afternoons were usually quieter than evenings, especially on a Sunday. Those who joined or stayed up late on Saturday evening, usually arrived later than that hour the next day. As I was walking around, somewhere near the Martyrs' Square statue, I stumbled upon a young man in his twenties, laying down on a bed made of a pallet and seat pads, leaning on his side with a cigarette loosely held in hand; as careless as one could appear to be. It was a still and timeless moment in which all the chaos and noise which the square would witness at night seemed distant. The photographic response to this sight was swift and succinct.

We made eye contact, and I nudged the camera I was holding with my hands, as a sign that I wanted to take his portrait, a minimal gesture, almost as not to disturb his peace. He nodded to grant me the permission and so I took two photographs of him. It was all in his gaze, the silence and the sereneness he emitted that appealed to me. I approached him after that to inquire about him, and we chatted for a brief moment. I learned that he was from Beirut and that he had been on the streets since the first day of protests, sleeping in a tent, and only going back home to shower or have an occasional proper lunch.

That brief visual exchange before taking the photograph felt reminiscent of the times when the photographer would ask their sitters not to move in order to take their portrait. He laid there, as effortlessly and as carelessly as one could. His direct stare into the camera turns the passiveness of the posture into an active challenge, a statement embodying his act of resistance. The pride he took in being there was palpable.

In that moment, he embodied the monumentality of a sculpture. He resembled the main subject of Manet's *Le Déjeuner sur l'herbe*, so tranquil and careless in the posture, yet so present and piercing through his eye contact.

"Your Lebanon is a political knot,
a national dilemma,
a place of conflict
and deception

My Lebanon is a place of beauty and
dreams of enchanting
valleys and splendid mountains
(...)

Your Lebanon is empty and
fleeting, whereas

My **Lebanon** will
endure forever."

Khalil Gibran, *The Eye of the Prophet*

CARMEN YAHCHOUCH

Beirut under the rubbles

Born in Bamako, Mali 1993, Carmen Yahchouchi has been in love with photography for as long as she can remember. Sensitive by nature, emotional and passionate about storytelling, Carmen tries to venture into the intimate spaces of human experience, propelling the spectator into the unique universe of each of her subjects. In September 2015, she won the fifth edition of the Byblos Bank Award. She has exhibited for Raw Talents at Beirut's Art Factum gallery in 2016 at Byblos Bank Headquarters; for Amman Image Festival in Jordan in the "New World/ Nouveau Monde" exhibition; for Workshop with The Arab Documentary Photography Program (ADPP); for the 32nd Salon d'Automne at the Sursock Museum; for the Italian gallery Remomero; for Blink and the New York Times Portfolio Review; for The Chania Photo Festival in 2017; for the 10th edition of the Estação Imagem Award in Coimbra, Portugal; for Les Rencontres Photographique De Rabat in 2019; and for the Photography International Festival called Phot'Aix in France that invited Lebanon for their 19th edition. Most recently, Carmen Yahchouchi has exhibited in Paris and Beirut to help the victims and survivors of the Beirut port explosion. Carmen Yahchouchi is currently a storyteller at Reuters.

I was born and raised in Mali, and after relocating to Lebanon in 2010, I pursued my Bachelor's degree in photography at Notre Dame University. While refining my skills, and developing a sharp eye for documentary photography, I began to understand my subject's gestures and demeanor. This enabled me to develop an aesthetic sensibility towards complex issues that many avoid, and the people I meet influence my work the most.

By listening and telling the stories of others, we come to understand that there are no stereotypes and that we stand as individuals. In storytelling, I feel empathy with my subjects, but the most important part is for them to feel empathy with me, and I capture the emotion they transmit and their surroundings. That's why photography seems to sit at the intersection of skill and humility. No matter the topic, or how distant it seems for you, it's not until you find yourself or examine your motivation to tell a story, that your story becomes compelling to others. I am a very emotional person and I discovered that big side of me while doing photography, and with time. Without knowing it, I started to see myself in my subjects 'intimate spaces'. They are teaching me things about myself, and they are showing me the world, this cold world; they leave their energies inside my soul for the rest of my life and that's the power of storytelling.

Following the Beirut port explosions on August 4, 2020, I produced many stories, as the aftermath didn't let any of us sleep. The Lebanese people were not afraid of the camera anymore since everyone you saw and still see in Beirut wanted to share their stories to the world and be heard. Certainly, art—including storytelling—influences society by changing opinions, instilling values, and translating experiences across space and time. Art remains a significant form of communication that must take up the challenges facing humanity today. No issue is more critical than the rapidly escalating destruction of our environment. The world of art must find a way to bring this message to as many on the planet as possible. If the "medium is the message", the art world must act, quickly and radically, to shake people's "comfort zone" and use the power inherent to this uniquely human activity so as to provoke widespread behavioral change.

As a Lebanese artist based in Beirut, I can say that the past decade has seen an extraordinary range of cultural activity in the city: a new renaissance, underlining what could now be lost. If you are lucky to have a job nowadays, just keep it whatever the cost or the salary, because the young generation in Lebanon is now SURVIVING. Following the October 2019 Revolution, the pandemic and the economic crises, the Beirut blast... everyone lost their jobs, homes, shops, and galleries. We all have so much anger that we need to get out and express, and I think art is the best way to do this.

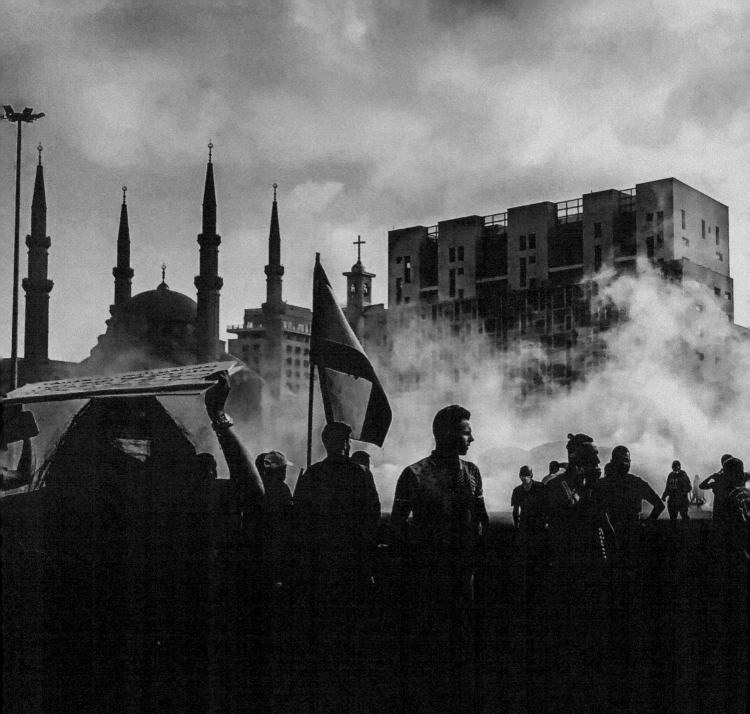

BEIRUT UNDER

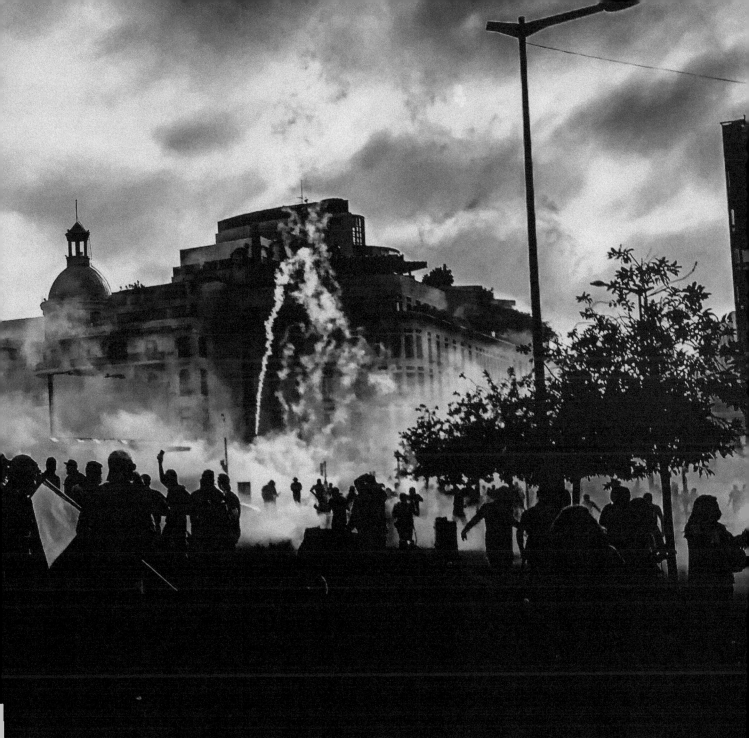

THE RUBBLES

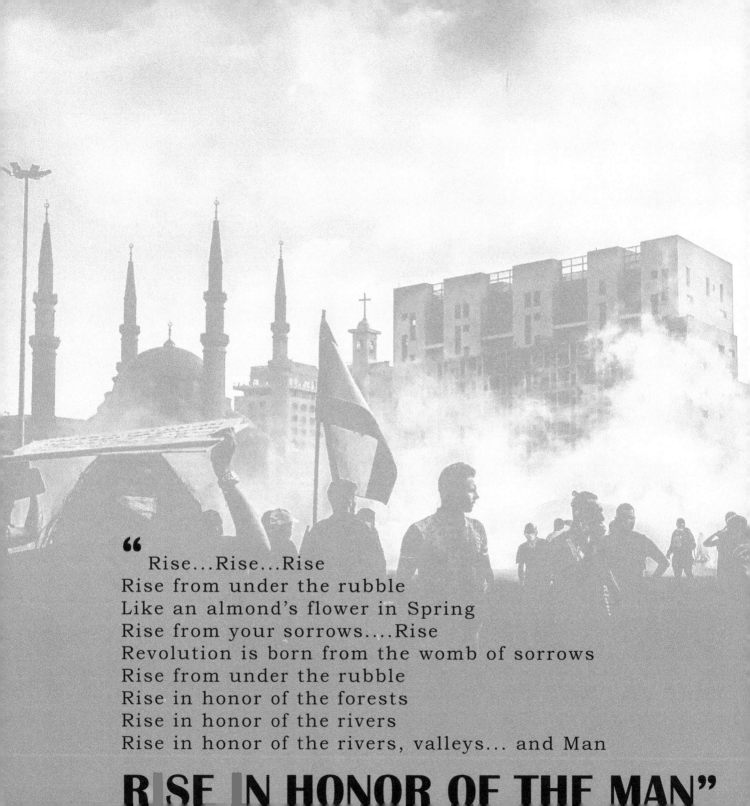

"
Rise...Rise...Rise
Rise from under the rubble
Like an almond's flower in Spring
Rise from your sorrows....Rise
Revolution is born from the womb of sorrows
Rise from under the rubble
Rise in honor of the forests
Rise in honor of the rivers
Rise in honor of the rivers, valleys... and Man

RISE IN HONOR OF THE MAN"

„
قومي... قومي... قومي
قومي من تحت الردم
كزهرة لوز في نيسان
قومي من حزنك قومي
إن الثورة تولد من رحم الأحزان
قومي من تحت الردم
قومي إكراماً للغابات
قومي إكراماً للأنهار
قومي إكراماً للأنهار والوديان... والإنسان
قومي إكراماً للإنسان"

Excerpt of Majida El Roumi's song, *Beirut Set El Donia*

FRANK DARWICHE

From the heart of Lebanon

Frank Darwiche is a Lebanese-French writer, translator, polyglot, university professor, philosopher, singer and songwriter. He obtained his PhD from the University of Bourgogne, where he worked on Heidegger's Fourfold. He has written numerous research articles on German, French, as well as Lebanese philosophy. His publications include *Heidegger: le divin et le Quadriparti*, a soon-to-be-published book on the Lebanese philosopher Kamal Youssef El-Hage, the narrative-poetic work *Le Liban ou l'irréductible distance*, and many scholarly writings on such diverse issues such as tolerance, Thomas Aquinas, non-rational thinking, Ibn 'Arabi, Heidegger's reading of Hegel, and phenomenological readings of the Islamic veil. He has taught philosophy at l'Ecole Nationale Supérieure d'Art, the University of Balamand and elsewhere. Additionally, he has been part of several contemporary music formations and is always exploring the creative process. One notable offering of his includes a collaboration with the Dijon-based La Générale d'Expérimentation, which consisted in touring Lebanese wineries and writing and performing songs, inspired by each visit, both in Lebanon and France. His aesthetics is always philosophically bound and fervidly lyrical, carried headlong by the passionate vehemence of creation. He currently resides in Lebanon and France and travels frequently.

SUNDAY MASS IN/AS BEIRUT

The church steeple rises from a Beirut street below,
Higher and higher as Gemmayzeh I descend,
Looming over a town still asleep,
On a quiet morning still,
Coloured only by a dull grey sky.

There are visitors come to that steeple high:
Blackbirds fallen from black clouds,
Dancing round it so long and fast,
That my eyes twirl with them, my mind falls asleep;
And I wonder, are we all turning round the steeple,
Or is the steeple turning round our heads?

My feet take me down, and down I go,
So the steeple gets higher, and the church ever close;
And so near do my eyes see that erected gloom,
That I wonder, am I going toward the steeple,
Or am I walking on the church and steeple ahead?

By the church steps, my steps with my body arrive,
And the steeple gets smaller, absorbed by the church:
Alas, I say, how the very one who needs raise the steeple to heaven,
Is always stealing the steeple from the sky.

The church door finally opens, and the wind rushes me in,
But I hear behind me the call of the rising Beirut sun;
So I turn around and look toward the dome above,
And stretch my hands toward where the steeple was:
The blackbirds hear my heart and descend to twirl round my head,

And the church and steeple sink under the earth,
Into the ocean of Lebanon's cemeteries,
Underneath my bed.

CRUSADER BYBLOS

There is a citadel in the heart of a bay,
By a thousand built in a thousand ways.
So little they knew what they had built
Would outlast their guilt,
And come home to me.

There is a town which stood at the side of a hill,
By a million sought, a million to kill.
Hardly they knew the cause they fought
Would slay what they brought,
And come torture me.

The sea tries hard the stones to reclaim,
And earth refuses to swallow this game;
So the citadel stands where I would,
My heart runs where never I could,
And leaves without me.

LEBANESE ELECTIONS

Turn the lights out and listen to the street:
The tattered posters are coming to greet
The stars above them and the skies below
Where politicians fight on to stop the flow.

Stand alone under the grim lamp,
Watch the girl lick the damp stamp,
While her dreams are shattered
And her body is battered
Looking for the drug of life.

Run till the sun slows and shines,
And the fishermen leave the fish for the shrines,
Lying awake at the threshold of dawn
On the wan glories of the thieves of old,
Donned in the promises of thrashing feet,
And the fleets of meat at the beat.

Close your eyes and try to see mine,
The plans we had and the children's grime,
Like a stool we hurl at the passers-by,
Drunk with lack of dough and wine,
As the arak wets the walled papers
We're about to burn.

It's election time again,
I can love you tonight!

BLASTED BEIRUT

Walking on the Promenade
In a Sunday morning light,
My best lank prostitute
And me.

I could see the eyes of Mars
Lingering behind the fireline.

Armstock,
Armstock,
I start to see.

Sliding on the Promenade
Wishing it were still our night,
My last prostitute
And me, and me.

Arm stock,
Arm stock,
I'm stuck, again

Leaving behind the Promenade
Still wondering if I am real,
Your burnt face from last night,
I'm again the prostitute of fear.

Arm stock,
Arm stock,

I'm stuck, I'm stuck.

I can't see.

(Song available as "Aucune Volonté - Blasted Beirut" on YouTube at:
https://youtu.be/aC0DpwLt8MA)

A LEBANESE CHRISTMAS

I stood with my face pressed against the windowpane, as I looked into a large room where men, women and children conversed and moved about happily in party mirth, ignoring the smell of Beirut petrol and kerosene. Flickering lights and Merry Christmas festoons, along with gaudy pictures of St. Charbel, hung above the smiling, greasy faces that celebrated the holidays. A smartly attired woman by the window was handing a sharply decked boy a present, which he opened forthwith to a pout. There was a young couple kissing in the corner under a high and sumptuous Christmas tree that flickered joy on the faces in the room. In the middle, many guests gathered round a large table with all sorts of delicatessens, drinking Beaujolais, Bordeaux and Champagne, and laughing the hours away. Loud music from two large speakers moved some drunken youths' feet to its rhythm. It drifted to my ears in distorted, indiscernible whines that mixed with the sultry sounds of richly clad people and clergy singing carols in the Church at the top of the street. A noise from two rabbits frolicking in a nearby bush caused me to turn away from this scene. I walked slowly down the cold and deserted street. I passed an old man sitting by the door of a closed store, bundled in rags and cardboard. I could hear him breathe and cough heavily. There were a few crumbs of bread at his side on the ground, and some rotten cheese on a piece of paper next to a dirty plate, where a single penny lay alone like its owner.

I could only hear the Church choir now, as I reached a part of the street where a few trees replaced shops and human structures. In the dark, I discerned a poor young girl gleaning Christmas ribbons which she put in her hair and tucked round her tattered skirt. She looked at me, smiled, and continued her exercise. "Merry Christmas," I said. She looked at me again, but this time she frowned, squeezed her hands, bit her lip, and ran away. Ten minutes passed before I met a young man dressed in white, sitting on a bench under a cankered oak tree with his head in his hands. I sat by him to catch my breath. "Good evening," I ventured, "Merry Christmas!"

He looked at me with tears flowing from his eyes. His face possessed a certain glowing, ethereal look that seemed tainted with a dejected expression of deep resentment and regret. I could now see that his clothes, although white in colour, were torn and smeared with blood. He also had what seemed like an old, forgotten book in his right hand, which he held tightly, and an old walking stick that had the appearance of a broken sword. I tried to converse with him and enquire about his plot, but he answered with nods and shrugs. He finally spoke when I asked him how he could be sad on such a glorious eve.

"I am sad because of this eve," he answered.

"But people are happy, partying and celebrating the season. Isn't that glorious?"
I protested.

"They are celebrating themselves and their lives," he retorted.

His answers became more enigmatic as my questions sought further elucidation.
He then proceeded to leave. "I have to go now," he declared.

"Well, wait," said I, "do you need some help, some sort of transport? Or can I buy you dinner?!"

"No, thank you!" he answered.

"Well, tell me, before you leave," I asked, "what is your name? Maybe we'll meet again."

He looked with bright, lamenting eyes to heaven, then down gently and ruefully at me, and drew a forced smile.

"Jesus," he answered.

MY TESTAMENT TO LEBANON

How to give the constant possibility of a disaster which has lasted fifty years a name? Should I bring out the moments of evanescent pleasure, trapped in the pleasure principle and avoiding the reality archè?

A disastrous country which was first a disastrous world, a limited, entrapping, hateful world, made up of confessional warfare in word and deed—a disastrous country it is and has continued unremittingly to be, ever killing any heartening thought, ever nagging to ridiculousness any serious endeavour for a serious way out, ever making friends into impossible, hopeless buoys, while the ship has continued its everlasting sinking into a sea of rubbish. Yes, this has been my life as a Lebanese, and yes, it has lasted this long, despite moving away, coming back and moving away again, only to feel the heavens tumble over me every step of the way.

When the war supposedly ended—and that is debatable… or perhaps it isn't since it really has never ended—but we may say that after the '80s war there came the '90s downward slope with a new-found hypocrisy, ignoring the corruption, religious fanaticism, a fake left supporting Islamist plans for the region and the world, a moribund extreme right with nothing to say except hide in a shell of lies and hate, a population surrounding itself with curtains of money to avoid witnessing the scene, a young generation of ignorant idiots ever more proud of their ignorance and love for money and desire to leave and become stupid engineers and doctors, fanatic unquestioning fools, the ever-stupider product of an ever-dying country with a border bursting internally at the seams.

The miracle that is Lebanon is the miracle of the longest-lasting lie to oneself, the region and the world. It is the battle for recognition from fanatics, capitalists, idiotic communists, despicable fascists with no name, singing non-prostituting prostitutes, to the background of pseudo-intellectual conferences, where an audience of a thousand listens to the first and vapid speaker and leaves when any serious words are said. It is

pride in a series of useless intellectuals made even more useless by their recuperation today, and a series of "successful" businessmen who keep the faith in money as the essence of the most ridiculous foundation a country has ever known, writhing in the guilty pleasure of hypocrisy, bathing in the heated calls of minarets and steeples, shaking the trees of pseudo-knowledge where, if Satan existed, he would have a blast.

The poet in me says blast them, blast it, give it all up! Whatever may still have a hold in this masquerade of turbans and ugly faces, let it burn with the rest of a political class and the country which pretends not to want that very class in power!

The thinker in me says objectify this into an uninteresting topic and a transient existence which history shall never mourn. May the canker continue on until this bit of a so-called patria and motherland is cleansed of its very self—perhaps something like Nature with no final causes could reclaim the heaps of corpses and rubbish which never cease to amaze the seagulls of hope and chance.

A testament this is to a despicable generation to come!

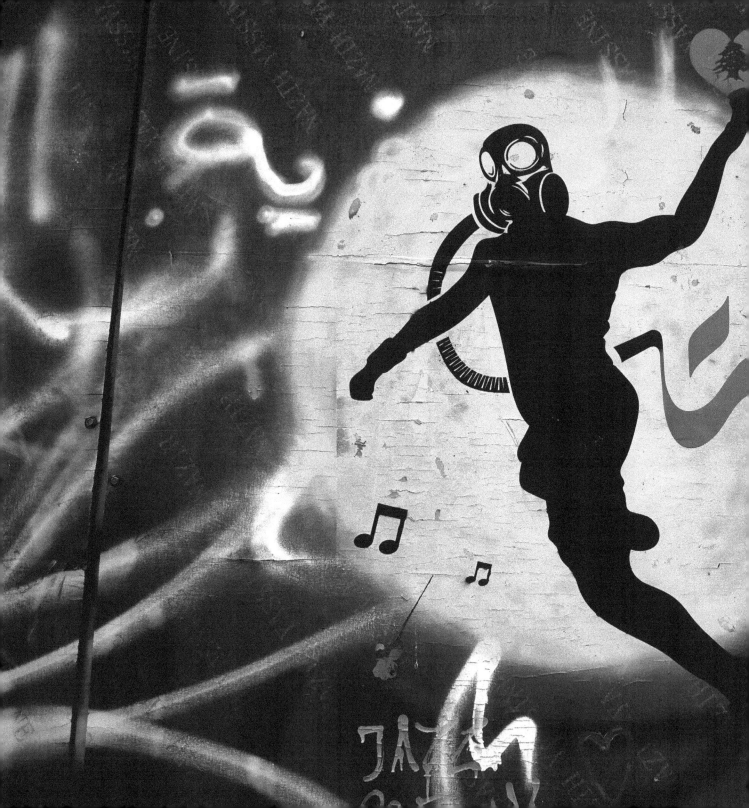

"We are all the products and victims of our own upbringing, until we **reflect**, **refuse**, and **rebel**."

Rawi Hage, *Carnival*

Little Fighter: A drawing of a protester fighting tear gas with love, in answer to police brutality that led to many citizens losing an eye or even their lives during the October 17 uprising.

NADA RAPHAEL

Beirut in a heartbeat

As an engaged artist, passionate about her country, Nada Raphael uses her diverse experiences to write articles and stories, take pictures, direct and produce documentaries, in order to raise awareness, express feelings, share different opinions and shed light on untold realities. With more than 15 years experience as a photographer, she held many exhibitions in Montreal such as *Hyphen Islam Christianity* in 2010, at the Gesù – Centre de créativité, Beirut Art Fair at the Artheum (for 3 consecutive years 2013-2015), and many more. As a filmmaker and a documentarist, her work was highly sought after around the world—*Irani-Afghani* (2002), a program about the Iranian filmmaker Majid Majidi who shot a documentary in Afghanistan only two weeks before the fall of the Taliban Regime, selected at the NFB Lebanese film festival; *Flash Back… Ou Ba3dein* (2007), portraying the Lebanese Canadians caught in the 2006 war in Lebanon, selected in many festivals such as the Festival des Films sur les Droits de la Personne, in Montreal; *Hyphen Islam-Christianity* documenting the many religious communities living all together in Lebanon, selected around the world, in 25 cities, shown in festivals and universities. As a journalist, she wrote many articles for the *Journal Metro, IN-Magazine, L'Avenir in Montreal* and animated her own radio show *Alf Layla Wa Layla* at CISM89.3 FM in Montreal. The book she co-wrote, *Hyphen Islam Christianity*, won the Special mention within the 30th France-Lebanon Award organized by the Association des Écrivains de Langue Française (ADELF) in 2010.

Don't say Beirut twice...

When I hear this word, I constantly feel I am missing a heartbeat, or losing sight of the bigger picture.

I was born in Beirut—in a Beirut torn between the old and the new, politics and religions, wealth and poverty, and art and science.

I was born on what used to be called the Green Line, a Green Line that had many colors, many phases and faces, many meanings... but mostly, for me, it was my playground, and afterwards, while growing up, my inspiration and my despair.

I left Beirut a long time ago, and flew far away. And she followed me every step of the way.

What or who is Beirut?

Beirut is a city; a city in the midst of time and wonders, a city where every street, and every district, has its own personality, specialty, people, and religion.

Beirut is the Capital, with a capital C—the place where everyone meets, befriends and unfriends, falls in love or breaks up.

Beirut is part of History, with a capital H—the history of many civilizations, many battles and wars, many dreams and movies, earthquakes and tragedies, walks and runways.

Beirut is a melting pot of cultures, colors and religions.

Beirut is an inspiration for filmmakers, artists, street artists and painters.

Beirut is a picture, or rather an album, where colors meet black and white; where 18th and 19th century palaces meet modern buildings; where paved streets lead you to the sea; where fishermen and businesswomen walk on the same path; where street vendors meet designer and high-end boutiques, and where the old Beetle races with the new Mercedes.

Beirut is a song that resonates in the heart of every immigrant—a song of gloominess, a song that whispers in your ears Come back, a tune that you irrepressibly hum even as you refuse to listen.

Beirut is a painting, or a drawing, or a mix of both.

Beirut is *red*, Beirut is *blood*—blood of the martyrs; blood of the people in the wrong place or the wrong time; blood of the revolt that runs in the veins of every man, woman and child; blood of despair, blood of hope.

Beirut is a *she*. Beirut is a *woman* who stands her ground; who educates and whispers the future of her children; a *woman* who leads, screams, and cries for the loss of her loved ones.

Beirut is a sound, or rather many sounds—the sound of honking, the yelling of street vendors "Kaak Kaak" or "3al Sekkin ya Battikh"[1]; the sound of boats arriving from faraway lands to the harbor; the sound of whistling; the sound of bombing; the sound of airplanes; the sound of hissing and whispering; the sound of people talking with each other and about each other; the sound of revolution, resilience, resistance, and hope.

Beirut is a story—a bedtime story that starts with *Once upon a time*; a nightmare where ghosts stay alive in every family, in every building; a love story where people meet on the Corniche, or in the old streets of Basta, Badaro, Zokak el Blat, Hamra, Geitawi and Gemmayzeh.

Do I hate Beirut or do I love Beirut? It is a complicated question.
I have my emotions, my memories, my childhood, my friends, my family...
It is more a sense of belonging than an emotion.
I hate Beirut and I love Beirut.

1 "Kaak" is the common Arabic word for biscuit, and can refer to several different types of baked goods produced throughout the Arab world. "3al Sekkin ya Battikh" refers to the cutting of watermelon.

I left Beirut a long time ago, or rather she left me…

Don't say Beirut twice…

Because I am and will always be Beirut.

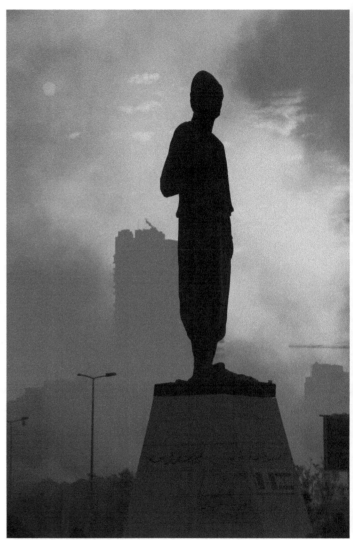

Angels: Angels come in all shapes and sizes and from all religious confessions. Women from across the country have come together in an unprecedented way, fighting against the same injustice, violence, and hardships, and all asking for peace. By just joining protests or lighting candles, their gestures go beyond religious and social divides. Women have been lighting so many candles for so long, that they have become their voice. They have replaced the sorrow in our eyes. They have become our prayers and our tears.

The Silent Whisper: The open sea, the Mediterranean basin, so full of history and trade and exchange. And in the midst of it all, people leaving their familiar shores to explore unfamiliar lands and to settle in new countries, fleeing war and economic hardships. Carrying their country in their hearts, their most precious belongings in their suitcases, and images of their lives in their minds. They leave, and yet they stay. They start over and yet they linger. Like a statue watching the blast unfurl, scathed, but firmly rooted. A silent whisper of our folly.

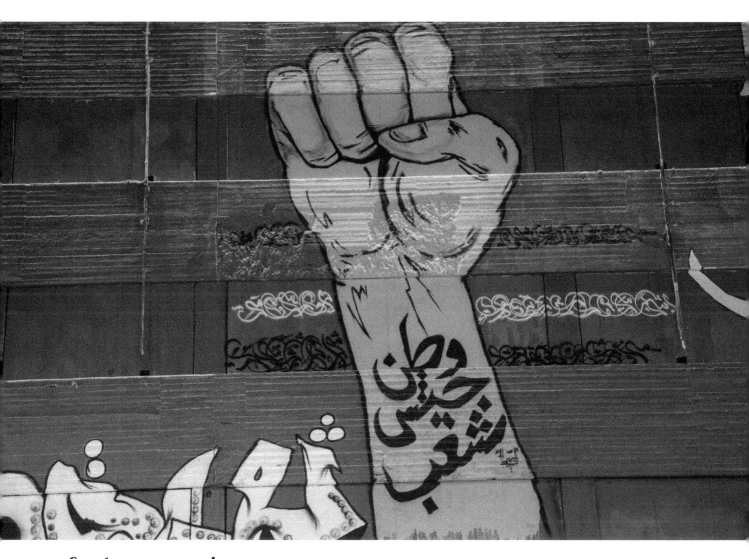

Country, army, people: One fist to rule them all. The fist of the Revolution. Of the uprising. Of a new voice, united, against a ruling class chipping away at our soul. Against a system worming its ways through our intestines. And yet, the army has proven its non-partiality. It has not taken sides with the people on any single occasion. So why is it mentioned on that fist?

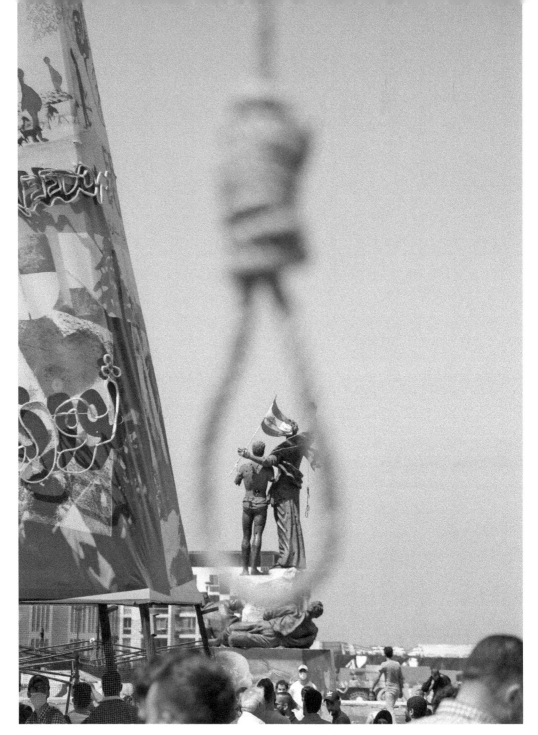

The lens: A noose to hang criminals. Or a lens to see through. A statue to remember. Or a one-way narrative to erase discrepancies. A picture to unite them all and under their rule, subjugate them.

Drums: So many sexist comments have been made by politicians against women that one has lost track—from the "stay at home and cook" to the forgiving of honor crimes. Much progress has been made thanks to the amazing work of many NGOs, but there is still a lot to do, starting with women being able to convey their nationality to their children. So meanwhile, women have used pots and pans to make their heartbeat heard; they will continue to find ways to raise their voices and assert their presence because half of the population does matter.

Hunger: Their lies starved us. Our bodies and our souls. The economy crashed, people lost everything. They are hungry. And hunger shouldn't be dismissed. Hunger is a powerful feeling. It leads to anger. Which leads to hatred. It's a vicious cycle, that can be equally good and bad.

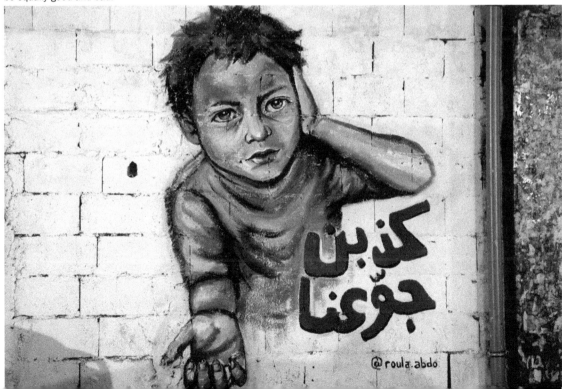

142

The Wall Of Fame: We are all in the gutter, but some of us are looking at the stars—Oscar Wilde

Tired But Not Defeated: Life takes its toll on us. Sometimes lightly. Sometimes heavily. And sometimes it takes a lot more. And yet, some still hang on. Because they are strong. Because they have support.

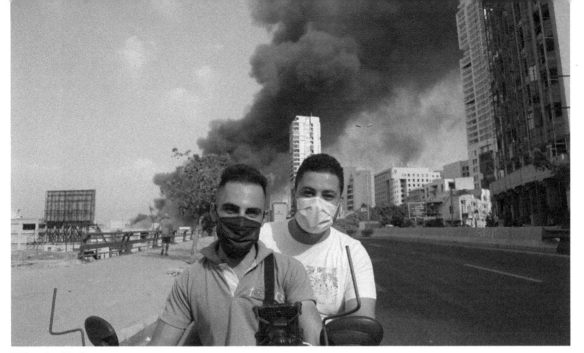

What's Up? Never stop smiling at the camera. No matter what's going on behind you.

For Alaa: For those who were killed by ignorance and hatred. For those who lost their lives in the face of tyranny and oppression. For those who were killed by an unfair system ruled by greed. For those who lost a loved one by the hands of a soulless creature protected by a heartless caste. For us, for you, for them. For Lebanon. May we meet again, under better skies.

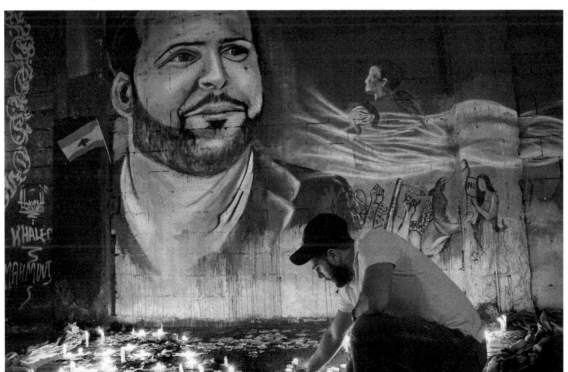

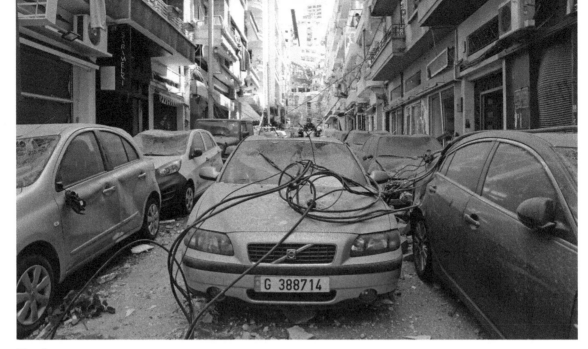

Mayhem: Is there another way to describe the capital in the first days following the August 4th blast? Is there another word to use when talking about an explosion that killed hundreds, wounded thousands, and displaced hundreds of thousands? Looking at it now, 6 months later, mayhem is a little word indeed.

Scream: A face screaming. A woman yelling. An urban painting, and people passing by. All of it collides in a city as old as civilization. All of it comes together, bridging past and present, the political and the arcane, the religious and the humane.

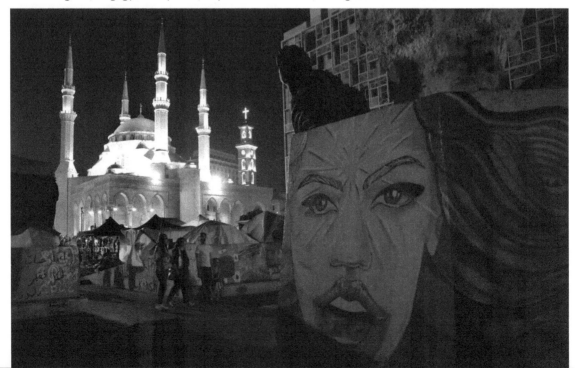

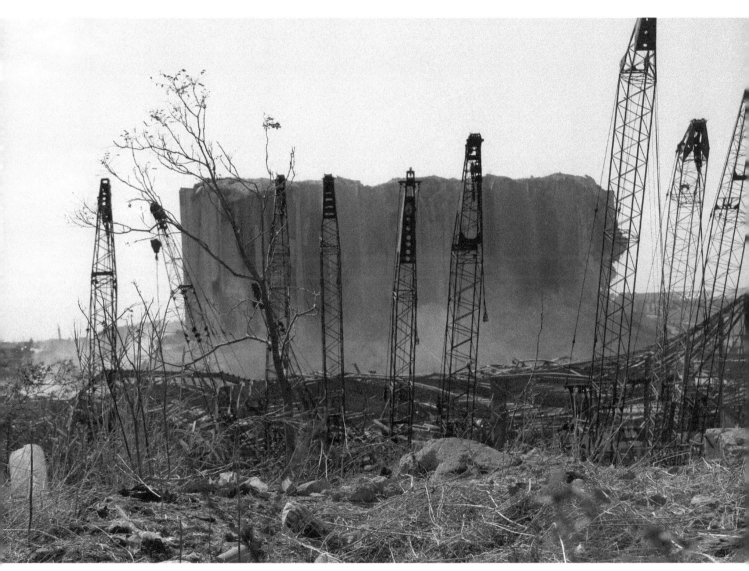

More Than Just A Story: A story of destruction and economic crisis. A story of negligence, and of crime. A story of architecture and trade. A story of how a city was born, how it was destroyed. A story of how people suffered, were traumatized, died, and how they came together and worked together. So many stories, so many names, so many faces. All turned towards the harbor and the blast; turned towards the sea and the promises of better lands.

NADIA WARDEH

A chat with Beirut

Dr. Nadia Wardeh is an independent scholar, university professor, writer, activist, passionate traveler and a coffee lover. She holds a higher diploma in Tourism from LaSalle College in Canada and a bachelor's degree in History and Philosophy from the University of Jordan. She pursued her higher studies at McGill University in Montreal, Canada: MA and PhD in Islamic Studies. Dr. Wardeh has an extensive eighteen years of multidisciplinary and international experience in higher education at institutions such as McGill University in Canada (2003-2008) and the American University in Dubai, United Arab Emirates (2009-2021). Dr. Wardeh obtained various awards, including from McGill University, the Research Council of Canada Award, and the American University in Dubai. She is an active participant in many international conferences and member of different organizations and higher education institutions. She is also the author of the book entitled *Problematic of Turath in Contemporary Arab Thought*, a number of book chapters, academic papers, and online artistic writings. She was recently appointed as one of two senior researchers by Dar al-Kalima University in Bethlehem-Palestine. She is tasked to create and develop an innovative syllabus as part of the one-year pilot project for more inclusive theologies in the Levant, in order to ensure human dignity, active citizenship, social coherence and tolerance. Dr. Wardeh participated recently in the 2020 Bethlehem Cultural Festival as a guest speaker, to address the question of Christian and Muslim religious and geographic perspectives on Bethlehem.

When the editor called me to contribute to this edition about Beirut, my heart told me that Beirut herself is calling, and today, I am responding to her.

To tell the truth, I felt ashamed and embarrassed as I know how many times we have failed and betrayed Beirut.

We have failed Beirut when we lost hope and believed that she had gone with the wind of injustice, oppression, and corruption. We have failed Beirut when we thought that she gave up and that she was about to surrender. Not only that, but we have also betrayed Beirut when we left her behind; grieving our absence ever since, she has been patiently waiting for our return.

Dear Beirut, kindly accept our sincere apology. We beg you to reopen your heart for us to repent and to confess that we have been ungrateful and ignorant souls to forget that your existence is actually your resistance.

I wonder, how have we overlooked the fact that you are "hard to die". How come we forgot that you, the grandchild of the phoenix, always rise from your ashes?

What would I say to Beirut or what can I say about Beirut?

Honestly, no words can convey my inner thoughts or depict my feelings. To me, Beirut is beyond rhetoric and nothing can befit her inimitable reality.

"The Wider the Vision, The Narrower the Phrase."[1]

So what should I say in my response today to Beirut?
I have an idea... Why not casually chat with this beautiful lady?

[1] This is a very famous quote by a tenth-century sufi mystic, Muhammad ibn 'Abd al-Jabbar ibn al-Hasan al-Niffarī, commonly known as al-Niffarī .

Yes, this is a good start but to begin with, allow me to close my eyes and open my heart to brainstorm...

Three things come to mind wondering why Beirut has chosen me for this task:

1. Beirut is calling her trusted people.
2. Beirut is waiting and opening her heart (again).
3. Beirut is longing for something.

Oh Beirut... Thank you for this opportunity. You have always been compassionate and forgiving no matter how ungrateful and insensible we, your folk, are. I confess that this is not our first sin. I am sure that you still recall how back in 1948, we left your sister Palestine behind and have abandoned both of you for decades.

So correct me if I am wrong...
I guess you are longing for a new start with your kinfolk...
You still have faith in us!
We are still the trusted ones!

Still brainstorming...

Even with our thoughtlessness, you are reopening your heart and inviting us to renew the bonds.
Absolutely... let us try again... let us get together and perhaps we will have a tiny chance to revive our relationship again.

But, is it possible? Don't you think it is quite tough or problematic?
Umm... maybe... but let us not forget that where there is a will, there is a way.

If we only recall the simple lesson we both learned in our childhood, we can definitely surpass this difficult trial.

First and foremost, we must remember that we, the Levantines, are skilled and capable of bringing life to life, again and again.

Who, other than us, can raise the living from the dead and the dead from the living? Every moment in our past and in our present testifies to this fact. It is indeed our reality and our fate.

We, the orphans of the Levant, need to evaluate what we remember and what we forget. What moments do we let go and what do we hold on to?

Indeed, the important thing to remember is the time when we were all in our motherland's—the Levant—custody before she was kidnapped and we were separated from her.

So the first step in our long journey must begin with a collective desire to revive our collective memory that goes back 105 years, to the moment of occupation and partition of our Home. We shall never forget that historical moment and must revitalize our collective memory to remember who we were and where we are standing today.

That is exactly what I am thinking, Nadia.
Let us start by getting closer to each other, so tell me briefly about yourself and how you see me in your reality or perhaps in your dream...

Sure thing...
I am Nadia Wardeh, the daughter of Jerusalem, and the granddaughter of the Levant. I am not an outsider or a stranger. We are relatives and soulmates. You are my sister in blood, in history, in resistance as existence, in culture and in fate. I know it has been a while... it has been since 1916 when we were forced to break up as a result of the British-French brutal mandates.

Like an orphan, each of us kept, in our hearts, some dark recollections of those

awful days. Yet, we promised ourselves not to forget and we have been determined to—at least—preserve our collective memory. It is that memory which kept us connected despite all of the catastrophes we have lived and experienced for endless nights and days.

It is our shared past and memory that have shaped the essence of our identity. Our motherland—the Levant—has taught us that our existence is defined by resistance. This fact explains how, until today, our art, music, clothes, food, and even our discourse and silence are all but multiple manifestations of resistance. This is indeed a reality and not a dream!

Therefore, since the dawn of our civilization—in times of peace or war and in times of poverty or prosperity—in the Levant, we have learned the art and the tactic of not only how to survive, but also how to be.

Oh Beirut, my little sister, thank you for opening your heart again. Believe me, we need you as much as you need us. We are excited about this call as much as you are, and we missed you as much as you missed us. Indeed, after 105 years of separation, we dearly yearn for your scent, your bosom, your touch, your mountains, your sea, your alleys, your mist and your rain.

To me, you are the last fortress in the Levant, the last hope, the buried glory, the escaping pleasure. Without a doubt, it is us who are in desperate need of you. We need the power and the determination of inimitable Beirut, the strong lady who, despite all catastrophes in the past, and the current suffering, remains committed to produce Goodness, Beauty and Truth.

I will say it again and again; we cannot be/continue without you...
Oh Beirut, my fair lady... who other than you can teach us the art of shining while fading... the art of presence while absent... and the art of living while dying?
Maybe this is why everyone is asking me about you...

Still brainstorming…

My students always ask about the specific impact of wars, occupation and the multiple crises on the culture scenes in Beirut. I always make sure that they learn the true meaning of the saying that "suffering creates creativity" and what is better than Beirut to embody this meaning.

Ironically, but not surprisingly, the catastrophes that befell Lebanon and the horror of the wars and the subsequent devastation, are the same ones that shaped Beirut's aesthetics and created its delicate artistic spirit. Therefore, I still teach my students that any destruction on the ground coincides with the construction of art.
Indeed, "creativity is born from the womb of suffering".

Why go far? If we only bring to mind some of the recent scenes of the October 2019 uprising and the August 2020 Port of Beirut's explosion, we see this fact as evident and clear. Even if we revisit Lebanon's old memory, we see that it is the different forms of artworks that remain in the conscience of the nation through today.

Do you not agree with me that the role of the art is greater and more crucial than we imagine?

When dispirited souls begin a path toward healing after each disaster, only artists keep them moving, no matter how strenuous and how impossible it may seem. Be it poetry, songs, or any other form of arts, the great artists in the Levant have undertaken the mission to transform our reality, to construct a new future and to keep our collective memory alive with their creative works.

To make a long story short, the state of art and creativity that occurred in Lebanon whether by Lebanese or non-Lebanese individuals, who either migrated, were displaced or fled there, show clearly that the production of art as creative resistance against all

facets of conflicts, including wars, colonization, occupation of the region, is apparent and well-exemplified in Beirut.

Surrealistically then, I see how the many catastrophes that befell Beirut have strengthened her immunity, made her live longer, and paved the way for the emergence of beautiful forms of arts. The cultural offsprings of the Phoenix have continued to resist. Every day they compose poetry, they paint and sketch, and they chant and dance. They are voicing our resentment and outlining our aspiration.

Armed with refined artistic tools, reclaiming the public spaces across Lebanon and yelling *"Kilun ya'ni Kilun"*,[2] your children took a new position, stood for their dreams and declared that they will continue the march until you are liberated again.

Oh my dear Beirut, I am quite sure that you are very glad to see your children rising from your ashes determined not only to be heard, but also to brighten the darkest moment of your and their long nights. How rewarding to observe them transforming public places into high-end art exhibitions, and to see how they continue to connect with their past. They celebrate the art form of resistance, and evoke a stream of patriotic enthusiasm.

As an observer of the October 2019 uprising/revolution, I also noticed the reviving of key poems/songs and of key artworks, revealing the intersection of Palestine and Lebanon. Who among us has not seen Handala—the core character and icon of the Palestinian cartoonist Naji al-Ali,[3] painted on the walls of Beirut as a symbol of bitterness, rejection and revolution.

2 All of them, we mean all of them—in reference to the government

3 Naji al-Ali was born 1937 in Al-Shajara, Palestine, and forced to leave in 1948 with his family. He settled in Ein Al-Hilwa refugee camp and joined the Arab Nationalist Movement in 1959. Ghassan Kanafani is a renowned Palestinian writer who published his cartoons in *al-Hurriya*, 1961. In 1963, he went to Kuwait and introduced Handala in 1969. In 1971, Kanafani went back to Beirut and worked for al-Safeer. He then published his first cartoon book in 1976. Kanafani was forced to leave Beirut in 1983, so he went to Kuwait and worked for *al-Qabas* newspaper. In 1985, he was forced to leave Kuwait to London. In 1987, Ghassan Kanafani was assassinated in London at the age of 50.

Let me remind you of the story of Handala as narrated by his creator:

Name: Handala.
Father's name: not important.
Mother's name: Nakbah.
Size of his shoes: does not know because he is always barefooted.
Date of Birth: June 5th, 1967 at the age of 10 years old.
Nationality: Simply an Arab.
Experience & Education: An Educated Arab person who knows all languages and dialects, knows all types of people: the good, the bad and the ugly, went to the battlefields and knows who fights and who just talks.[4]

From Naji al-Ali's perspective, Palestinian and Lebanese suffering are two sides of the same coin. He sketched the following words in a cartoon in the early 1980s to express the state of corruption and injustice suffered by the Palestinians and the Lebanese collectively:

You and I do not have electricity
You and I do not have water
You and I do not have health care
You and I do not have pension security
You and I do not have paved roads
You and I must demand an honest judicial system, that protects you and protects me from the ruling of the corrupt and the bad.
The same corrupted one is still stealing both of us.

4 Fayek Oweis, "The Cartoons of Naji al-Ali: Characters, Symbols and References," *Ask Dr. Yahya*, http://www.askdryahya.com/Naji-alaliHanzala.pdf.

This is a tribute to this creator, who was born from the womb of suffering and showed us that **"the word and the line drawn, have a stronger force than bullets"**.

He was absolutely right, Nadia.

Although he passed away in the mid-1980s, his words and lines drawn live to this day and are seen up on the walls and buildings across my streets and squares.

Indeed, the collective memory of different age groups is present on the Lebanese scene. In addition to Naji al-Ali's "presence" in the 2019 uprising in Lebanon, other iconic classic artists were loudly present. Across all your streets and squares, my dear Beirut, we also listened to songs that were more than a quarter of a century old; voicing revolution, rejection, martyrs, resistance, peace, war, displacement, life, death, freedom, hope and despair.

To mention only a few, the songs of Fairuz, Julia Boutros and Marcel Khalifa, were played and chanted by all of the participants, regardless of their ideological views. One cannot overlook the role of those artists in preserving the nation's historical, political, socio-cultural and emotional collective memory. For decades, they have tried to instill the public with daily dynamism and a simple yet refined language that I like to identify as a poetic resistance, or an artistic patriotism.

No one ever failed to recall the 1967 Fairuz's song, "Zahrat al-Mada'in". On behalf of Lebanon and the Levant, Fairuz chanted and prayed for Jerusalem. She has foreseen that no peace would prevail in the world unless Jerusalem is liberated from the Zionist occupation and Palestinians could return to their homeland:

For you, City of prayers, I do Pray
For you, Beauty of all residence, rose of all cities
Oh, Jerusalem,
City of prayers, I do pray
To you, our eyes travel everyday
Tour the temples' corridors
Hug the old churches
And wipe sadness off mosques
...
The baby in the cave with his mother; Mary, two faces crying
For those who have been displaced
For homeless children
For those who defended and have been martyred at the entrances
And peace has been martyred in the home of peace
And justice fell at the entrance
When Jerusalem fell
Love stepped back and in the world's heart, war has settled
...
Bright anger is coming ... I am all faith
Bright anger is coming
I will pass over sorrows
From every path coming
With horses of fear coming
...
The door of our city will never be locked as I am going to pray
I will knock on the doors ... and I will open the doors
And you, Jordan River, will wash my face with your holy waters
And you, Jordan River, will erase the savage footprints
And it will defeat the face of power
The house is ours
And Jerusalem is ours
And with our hands, we will restore the beauty of Jerusalem[5]

5 Fisal, "Rose of all cities," *Arabic Language Blog*, August 31, 2011, https://blogs.transparent.com/arabic/rose-of-all-cities .

Dear Beirut, thank you for such a lovely song that was born from the womb of occupation and injustice. You always stand for Palestine and we shall never forget.

I agree with Mahmud Darwish[6] when he declared that Beirut become our "song and the song of everyone without a homeland". Who better than him can describe our attachment to you:

Beirut is the place where Palestinian political information and expression flourished...the birthplace for thousands of Palestinians who knew no other cradle...an Island upon which Arab immigrants dreaming of a new world landed. It was the foster mother of a heroic mythology that could offer the Arabs promise other than that born of the June war...[7]

Actually, Darwish wrote hundreds of verses to and about Beirut. His poetry left us with a full record of all events and stories of displacement and wars written in a refined lyrical language. Therefore, his voice reached the masses, especially when composers and singers adapted his poems into revolutionary songs. For years, the arts of friendship of Mahmud Darwish and Marcel Khalifa have produced a beautiful popular symphony that elevated the level of political awareness among the masses.

For example, it was immediately following the brutal 1982 siege of Beirut when Khalifa selected some lyrics from Darwish's long poem Beirut and turned it into the song, "Beirut Our Star", to recount and remember the tragedy of the siege:

6 A renowned Palestinian poet (1941-2008).
7 Mahmud Darwish, *Memory of Forgetfulness: August, Beirut, 1982,* trans. Ibrahim Muhawi (University of California Press, 1995),

Beirut as an apple and the heart does not laugh
our siege is an oasis in a world that dies
we will dance the field and marry the lilac
Beirut our tent
Beirut is our star
Beirut, we will not leave the ditch, Until the night passes.
Beirut for the infinitude, And our eyes for the sand
At first we were not Created,
At first... was the Word...
And now in the ditch, pregnancy traits have emerged.

What a fate my dear Beirut...

Every time you come out of labor, you get into a new one. How many resections you have undergone in your long laborious journey... I am pretty sure you are drained. To tell you a secret...I wonder how you are able to breathe in such toxic milieu...
Tell me: what encourages you to continue the battle or the race?

It is my turn to tell you a secret Nadia...
Of course I am exhausted, shattered and drained. There were many times I felt that I lost faith... many times I was close to surrender or to give up on my sovereignty and freedom. But guess what? My young children keep reminding me of my duty and my fate. They remind me that I should never stop fighting or lay down my arms!
Did you not hear the song of my daughter Julia?[8]
Her songs to resist, to rise up and to not give up our freedom, to resist in order to exist were played across my streets and squares...

8 Julia Boutros is a famous Lebanese singer who was born in Beirut in 1968.

Certainly my dear Beirut. I was thrilled to see how, after almost two decades, one of Julia's many songs was the core slogan used by young revolutionists in all parts of Lebanon to stress a simple, yet costly fact: freedom.

I agree with you, and I see that this is the reason for your call. Indeed, without freedom we vanish and die. Julia figured it out and chanted out loud:

I breathe freedom, don't cut off my air

...

You can never erase me, you need to listen to me and talk to me
And if you think it's curing me, this is not the remedy
If only you would listen to me,
All that happened should be enough

...

This world is big enough for everyone,
The truth alone remains

...

The voice of freedom remains louder than all the voices
However violently the wind of oppression blows and the night covers the spaces[9]

...

My dear Beirut,
You deserve nothing but the fresh air of freedom, embroidered with threads of sunray and painted with rainbow colors that suits your reality as an elegant beautiful fighter.
Nothing can beat you, my fair lady, you taught us the art of shining while fading, the art of presence while absent and the art of living while dying!

9 Jesa, "Breathe Freedom," *Arabic Language Blog*, July 22, 2013, https://blogs.transparent.com/arabic/breathe-freedom/ .

Oh Beirut, what is more brilliant than Mahmud Darwish's words in portraying your beauty and in revealing your secret:

Beirut
An apple for the sea, marble narcissus flower,
Stone butterfly,
Beirut
Shape of the soul in a mirror
Description of the first woman, smell of early mist
Beirut is built of gold and fatigue
Of Andalusia and Damascus...
Beirut [10]

10 Mahmud Darwish, "An Apple for the Sea," trans. Lena Jayyusi, *Poetry Nook*, https://www.poetrynook.com/poem/apple-sea-marble-narcissus-flower. Of note, the author used parts of available translated texts in English but made substantial changes to the translations.

"Handhala in Lebanon", Beirut, November 2019.

"Lebanon's Intifada, We all are one heart", Beirut, November 2019.

"Jana's Revolution", Beirut, November 2019.

"Heroes", Beirut, November 2019.

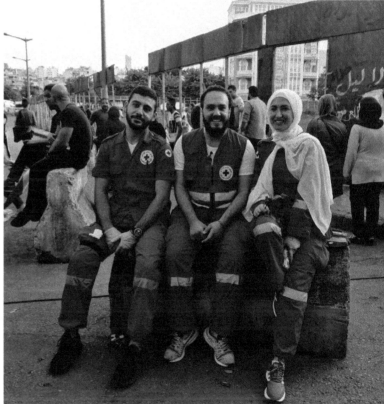

"Revolution Phoenix Sculpture", Beirut, November 2019.

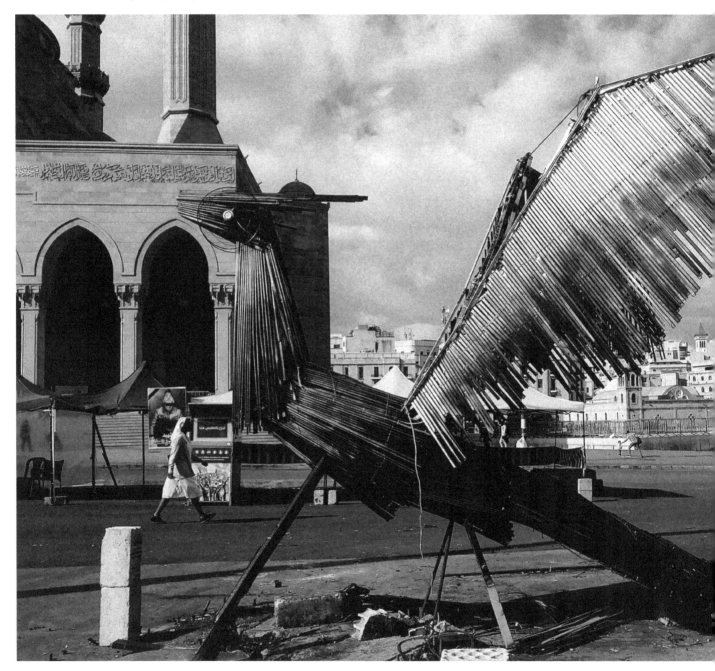

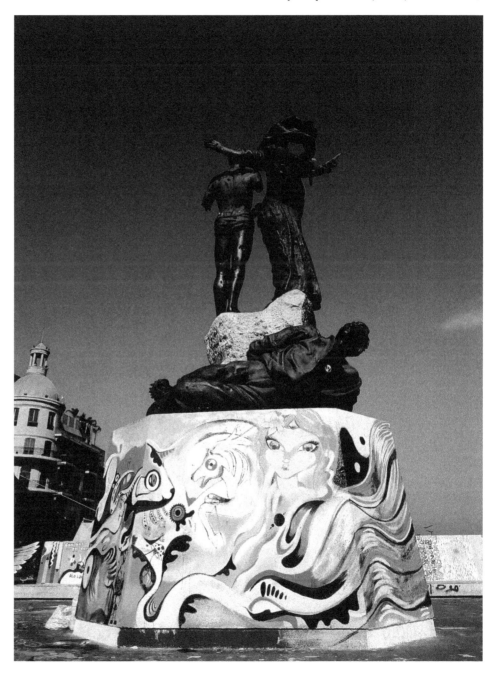

"Martyrs' Square 2019", Beirut, November 2019.

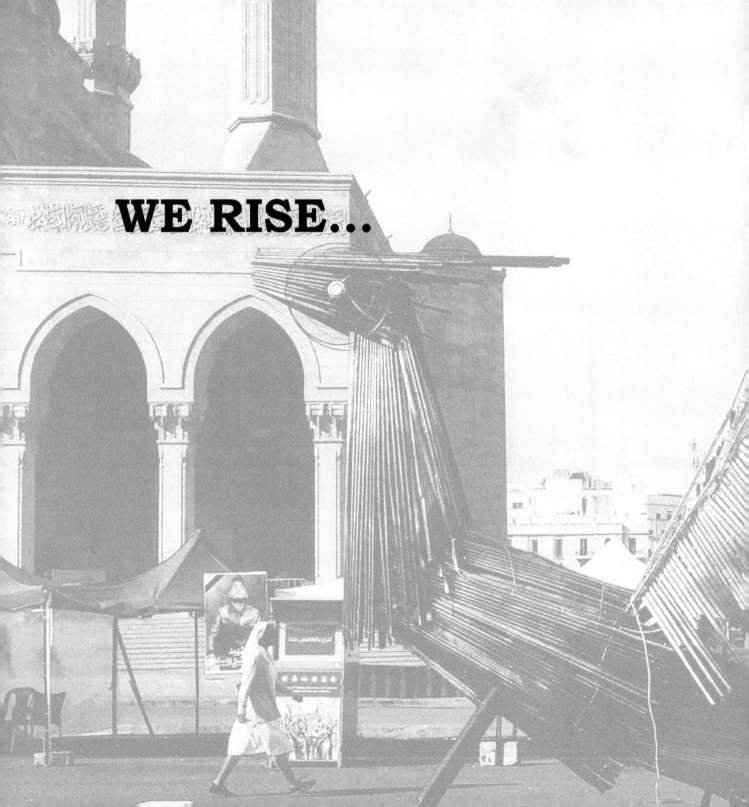

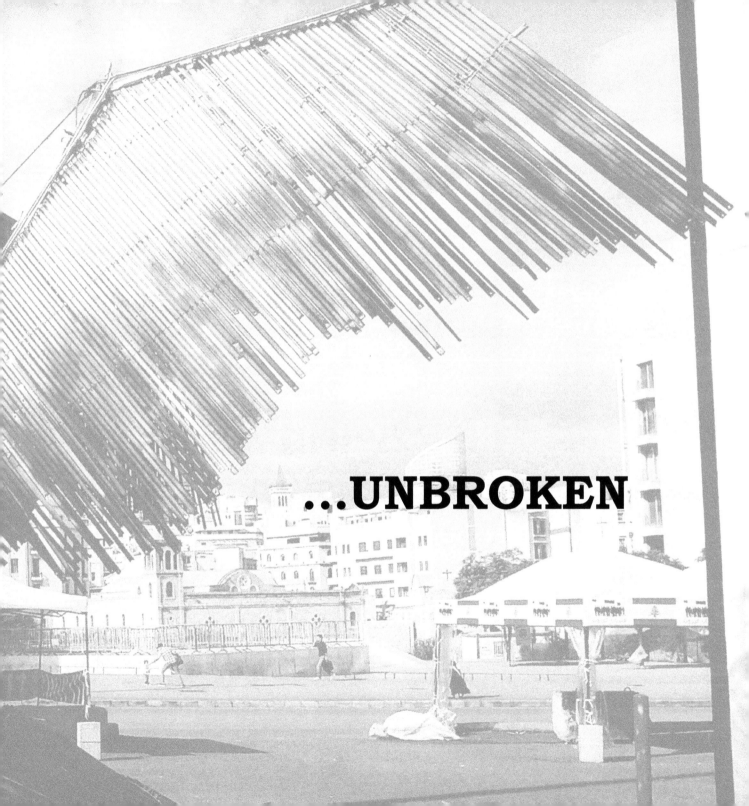

...UNBROKEN

"Beyrouth
est en Orient le dernier sanctuaire où l'Homme peut s'habiller de lumière."

"Beirut
is in the East the last sanctuary where Man can dress in light."

Nadia Tueni, Beyrouth in *20 poèmes pour un amour*

"Lunch break", Beirut, November 2019.

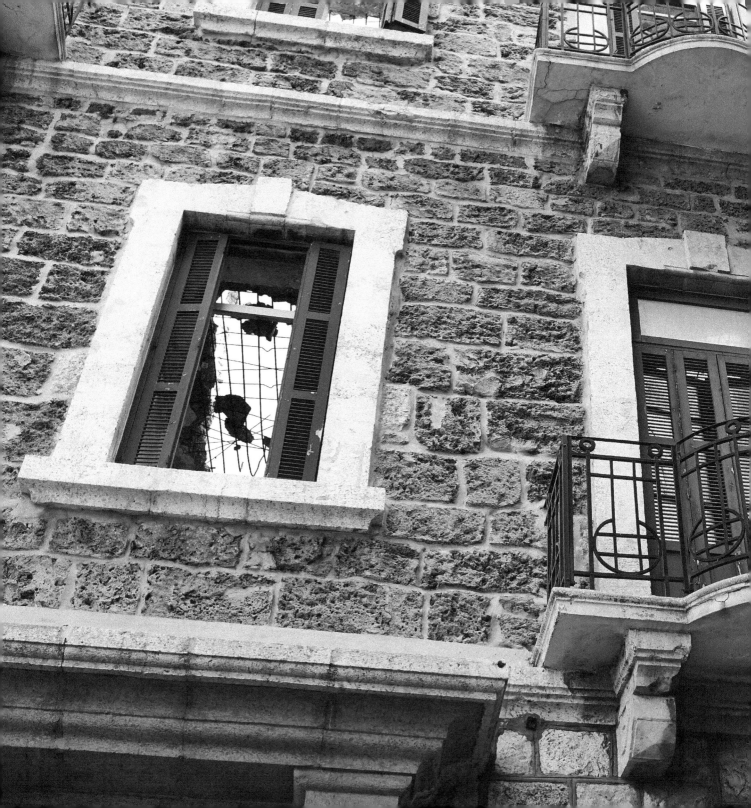

Exuviae: A shell of a building in Beirut, renovated from the outside, but left to despair on the inside.

DORINE POTEL DARWICHE

The blast of a sparkle

Dorine Potel Darwiche is a French photographer and visual artist. She also worked for 8 years as a production assistant and photographer for BUT furniture catalogues, in France. That experience influenced her thinking greatly, as it confirmed once and for all the power of various forms of discourse and image manipulation, as well as the fragility of our imagination. Henceforth, in creating or shaping her images, she has paid careful attention to what we see and the questions we ask, as well as our imaginary, while avoiding one-sided interpretations. Photographs and videos are, for Dorine Potel, two ways of keeping in direct touch with the world, hidden as it is under its endless representations. Her artistic practice consists of performative installations made for photographic work, short films, and other artistic forms, in surprising, unexpected and misplaced narratives. She builds up a dialogue between the real and the artificial, moving between utopian and apocalyptic «atmospheres». The magnifying and staging of details have often directed her approach to imagery. She currently lives and works between France and Lebanon. Her work has been exhibited at Rashid Karame International Art Fair in Tripoli, Beirut art center, Espace Gred in Nice, the International Photography Festival in Lianzhou, China, the Baudoin Lebon Gallery in Paris and the headquarters of the French General Confederation of Labour, CGT, in Montreuil.

I cannot speak... and so I take pictures.

I live in a country which I still don't quite know, but which I trust, because I trust the person which I have grown into and continue to become. Since I arrived in Lebanon four years ago, my network of endless associations has grown exponentially, to a point where it now fascinates me. I trust neither words nor language. The simple fact of understanding each other, as human beings, has always seemed incredible or even dubious, to me and not only because I do not speak the language. It is impossible to use words to understand each other fully.

Somewhere—in this place I'm in—understanding escapes me, and reality resides specifically in the (hi)story being told, the (hi)story trying to break unto the surface, before it plummets again into chaos. The art of surfaces is that of the filmstrip. Photography is the accumulation of surfaces. The camera is the instrument which allows us to meditate upon the order being created under our very eyes. Photography is the means to seize form at the very moment wherein it resembles a majestic structure, right before it bursts again into thousands of details.

(Parce que je ne sais pas parler, je fais des images. Je vis dans un pays que je ne connaissais pas mais à qui je fais confiance, parce que je fais confiance à l'adulte que je suis devenue et deviens encore. Arrivée au Liban il y a quatre ans, le jeu des associations s'est fortement amplifié, au point de me fasciner. Je ne fais pas confiance aux mots, ni au langage, et il n'y a pas que dans un pays dont je ne parle pas la langue que le simple fait de se comprendre, d'humain à humain, m'a toujours semblé incroyable, voire suspect. La compréhension me semble impossible, souvent au-delà du langage.

Quelque part, à l'endroit où je me trouve, la compréhension m'échappe et le réel réside précisément dans l'histoire en train de se raconter, l'histoire qui cherche à poindre à la surface avant de retomber dans le chaos. L'art de la surface, c'est la pellicule. L'accumulation de surfaces, c'est la photographie.

L'appareil photo est l'instrument qui permet de méditer cet ordre qui naît sous le regard. La photographie est le moyen qui permet de fixer la forme au moment même où elle ressemble à une structure majestueuse, avant d'exploser à nouveau en milliers de détails.)

POWER KEY 2017

FILMS , 2018

MONEY , 2019

BEIRUT SOUK , 2018

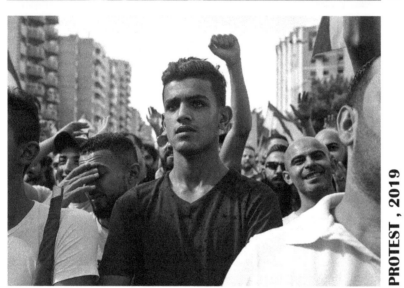

PROTEST , 2019

PORTRAIT , 2017

GIRLS IN HAMRA , 2018

CINEMA , 2018

DVD SHOP , 2019

ROULA AZAR DOUGLAS

Beirut. Darkness is dawn not yet born

Roula Azar Douglas is a Lebanese-Canadian author, journalist, lecturer and researcher. She has hundreds of published articles to her credit, as well as multiple collective works and two novels. Committed to combat discrimination and injustice wherever she sees them, she writes to trigger reflections, and to contribute to the evolution of mentalities and to the development of new approaches for achieving gender equality and social justice. Her latest book, *Le jour où le soleil ne s'est pas levé* (The Day the Sun Didn't Rise), was short-listed for the 2020 Hors Concours des lycéens Literary Award. It tackles euthanasia and sheds light on our fragility as human beings and our strength when facing upheavals. Roula Azar Douglas teaches journalism and writing at Saint Joseph University and the Lebanese University. She is also in charge of a weekly page on universities and youth at the leading French-speaking newspaper *L'Orient-Le Jour.* She is a PhD candidate in information and communication science at Saint Joseph University. Her research focuses on the role played by the Lebanese media in advancing gender equality. She holds a bachelor's degree in biology from the American University of Beirut, a Graduate Studies Degree from the Université du Québec in Montréal in Education, a joint master's degree in Journalism from The University Paris-Panthéon Assas and the Lebanese University and a Degree in Creative Writing from the Institut de Formation Professionnelle de Mont-Royal (Canada).

"DARKNESS IS DAWN NOT YET BORN"[1]

Since ancient times, Lebanon has always been associated with the phoenix rising from its ashes, determinedly spreading its wings and soaring high in the sky. This is but a romanticized image. Yet, in recent history, it has succeeded in instilling in the Lebanese people the courage and endurance needed to face the many misfortunes that continuously befall them—a much flaunted resilience indeed, and one that serves the interests of our leaders by helping them dissociate themselves from the security, political, social, and economic series of crises that the country is going through— with said series being indirectly presented as an unrelenting twist of fate. So today, I won't use the phoenix to describe Beirut. Especially because, in truth, it is the image of Sisyphus that has been on my mind since August 4, 2020.

To this day, still choked with anger, I search for words to describe what happened on that doomed early evening: the thundering cloud ripping through Beirut; the massive shock wave smashing the future of hundreds of men, women, and children to smithereens and shrouding the lives of thousands of others in black. Entire neighborhoods turned into ruins in the blink of an eye. Crumbling buildings, collapsing walls, shattering windows and cries of despair filling the streets...

I didn't cry on August 4th, nor did I cry the next day. Dazed and shocked, I ran to check on my parents. They're in their eighties and I can still not fathom how they made it out alive despite the enormous damage that was sustained in their apartment. The first tears didn't fall until two days had passed. It was not because of anger, suffering, or sorrow. Rather, they were caused by the overwhelming emotion that washed over me when I witnessed the spontaneous outburst of solidarity emanating from a group of young women and men who had come from afar to lend a helping hand to the residents of the affected neighborhoods. They helped them clear their homes from debris, save what could be repaired, and sweep the streets clean.

1 Gibran Khalil Gibran, *The Garden of The Prophet* (Britain: Read Books, 2019).

During the months that followed August 4th, it is my pen that saved me. I clung to it like a drowning person clings to a lifeline. Some rolled up their sleeves and took to the streets, others retreated into themselves. I started writing. And it was writing that allowed me to keep my head above water during those first weeks following the tragedy. Alexandra, Elias, Isaac, Ali, Ahmad, Sahar, Diana, Samir, Joe, Samer, Charbel, Krystel, Hassan, Ralph... I called out their names on social media and everywhere I went. Each one of them. All the victims. One by one. I did it to prevent them from turning into mere

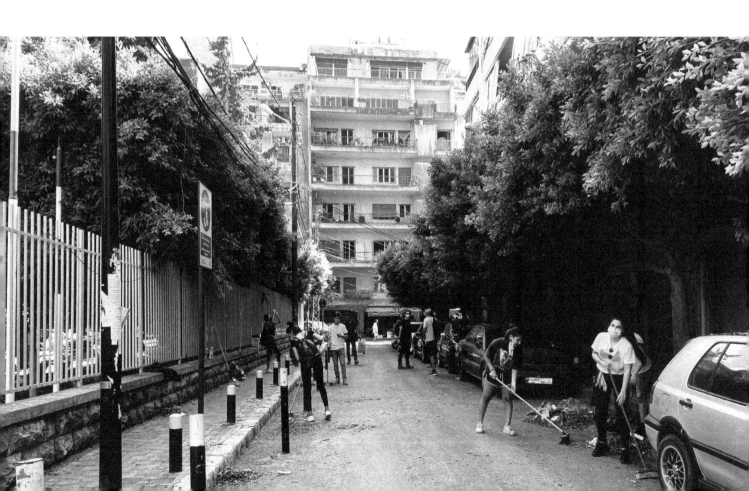

statistics. I tried to tell bits and pieces of their stories, fragments of the dreams they carried. I shared their smiles and bright eyes, and I imagined what their lives would've been like if other leaders were in charge of this country. Because this disaster was preventable. The suffering, bloodshed and destruction were preventable; but that's a different story. A story of institutionalized crime, conflicts of interest, corruption, treason, impunity... A story of the low value of human life in Lebanon... A story of 2,750 tons of ammonium nitrate left with no security measures in a warehouse, just across

from people's homes... Armed with photos and fragments of life, I spent long days and nights fighting oblivion. By shedding light on the victims, I was also honoring Beirut.

Beirut, which I have left "permanently" twice. Beirut, to which I have inevitably returned. Beirut, over which hovers today, like a permanent fog, a double nostalgia: the longing, not always defined, for a bygone era that marks the stories of our elders and the yearning, more excruciating than exile, for a bright future that seems to drift further away with every passing day... Yet Beirut is not a mirage. And despair is not inevitable.

For this dark night to come to an end, the call of life must be answered. All together, we shall emerge from the abyss: the most resilient pushing the others up front, helping them shake themselves up, sharing with them a breath of fresh air, reminding them of a thousand reasons to straighten up and hold their head high, to stand up, to build and rebuild, reclaim their city and reconcile over time, and to bring our future back to life. And this is where art will help us make it through. Art in the broadest sense of the word: certainly, the art that charms, but above all, the art that mends, soothes and heals; the art that nourishes the heart and soul; the art that enlightens; the art that uplifts; the art that prompts action. And most importantly, the art that can lead to the understanding that resilience is not synonymous with resignation.

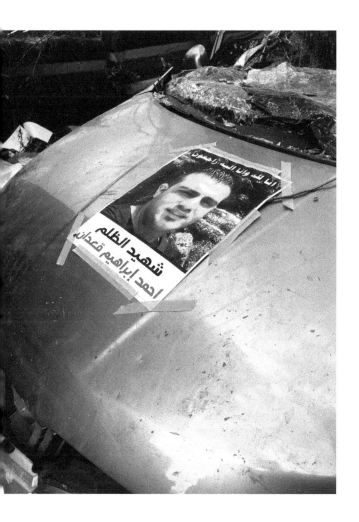

WADIH AL-ASMAR

Is art a basic need ?

Wadih Al-Asmar is co-founder and president of the CLDH (Lebanese Center for Human Rights) as well as Co-founder and board member of the FEMED (Euro-Mediterranean Federation Against Enforced Disappearance). In the summer of 2015, Wadih helped found the Lebanese social movement #tol3etRy7otkoun (#youStink), which actively helped organize and support social demonstrations during the last garbage crisis in Lebanon. In addition, Wadih Al-Asmar actively participated in the drafting of several laws related to human rights in Lebanon, such as the law on the criminalization of torture, the law on the creation of the National Human Rights Institution, and the law dealing with the issue of enforced disappearances in Lebanon. His work on human rights at the regional level is mainly within EuroMed Rights for which he has been a member of the executive committee, and was elected as President in June of 2018.

In the past years, Lebanon was facing a cascade of catastrophes that jeopardized the ability of people living there to sustain their basic needs, not to mention their fundamental rights.

The 4th of August Port of Beirut blast has to be analyzed in such context, and it isn't a simple catastrophe in a normal country: it was one more catastrophe in a falling-apart country. Such a live demonstration that troubles never comes singly.

In the middle of this fall, activism in Lebanon faced a shift in priority, especially in the first days of the catastrophe. Almost every single organization and individual were mobilized to work on humanitarian help. However, days later, we noticed that the needs of people were beyond having food and housing; people were in shock, and they were deeply in need of feeling 'normal' again. This feeling to get back to normality was the drive for many activists and organizations to resume their previous work.

This blast, coming after the unprecedented economic crisis, had an exponential effect on the pain felt by the people living in Lebanon. The immediate impact on the institutional arts and culture scene was huge; most of the cultural activities were canceled due to financial reasons and the pandemic. Most of the art-oriented organizations and companies stopped working, waiting for a better time. On the flip side, a new initiative emerged; people felt the need to express themselves and feel that they were not a cog in a failed machine, but they were still human, and what's better than art and culture to assure you that you didn't lose your humanity out of pain?

As a human rights activist, I noticed that mainly street art activities, traditional art shows, and many cultural events were organized to collect funds to rehabilitate victims and the city. A few art fairs were organized to make sure that we were still alive.

Those artists, I would say artivists (a smart mix between Art and activism), participated in supporting the community to stand up again. They were the ones who reminded people that they are human, that their needs go beyond food and housing. They helped human rights activists bring the discussion back to the rights of people and the duties of the rulers of this country.

Supporting those artivists would be by recognizing first, that art is not secondary; art is as important as our basic needs. It's also supporting the fact that art is not only about merchandising, but also about means and aims. There are many ways to support the arts, definitely through financial support and by spreading the Art so it reaches the maximum number of people. By helping them to sustain their activities and spreading their message to people, artivists are supported.

Artivists are not only here to sell art; they are an essential part of the fight for a better humanity; they can help to reach out to a public that might not hear or even understand savvy discourse on the needs for political changes, and on the rights or on the risk for our lives that come from the environmental crimes daily committed on our region.

We already have seen success with Art supporting a key political battle. For example, the fight against apartheid in South Africa, where the artist's and singer's implication, was a powerful support in the boycott campaign that finally brought down the apartheid regime.

We can state that we might be far from this in Lebanon, but this is not true. The impact that artists have on society and behavior has to push for a better place to live, not as a part of the existing confessional and political schemas. One way out of crises might come from the cultural and artistic area more than through the purely political arena.

Today, someone can't be an activist in one domain and believe that they will alone find the way. I believe that the only way to move forward is to combine multiple types of activism. In this approach, Art and culture are the most important, because they are more down to earth, and speak more to people than other concepts that might be very complicated to explain.

I believe that the cultural and artistic movement has started its revolution, but is straying from the traditional paths in Lebanon. By questioning some artists' attitudes that see Art as a cash machine and not as a way to participate in a nation's build, many boycott campaigns of unethical concerts. We notice fewer and fewer artistic public figures supporting the ruling parties.

I believe that the art scene in Lebanon is going to be a vital part of the front line in the fight for a democratic state, and this will come from the new generation of artists that are also democratizing the Art itself.

Good Morning Neighbor: The view from a typical house staircase that leads to the main street. Those staircases were a common sight in the Gemmayze area in Beirut.

"Beyrouth

est l'Elizabeth Taylor des villes : démente, magnifique, vulgaire, croulante, vieillissante et toujours en plein drame. **"**

"Beirut

is the Elizabeth Taylor of cities: insane, beautiful, falling apart, aging, and forever drama laden. **"**

Rabih Alameddine, *Les vies de papier*

ANTHONY SEMAAN

We all have to adapt

Anthony Semaan is the co-founder of Beirut Jam Sessions, an organization which produces music concerts, sessions and festivals in Lebanon and the Middle East. Since its inception in 2012, he has worked on hundreds of shows in Lebanon and around the world, both under the Beirut Jam Sessions umbrella and numerous other collaborative entities. He has been a key member of the Byblos International Festival since 2015, a consultant for numerous music related brands and has managed many emerging artists in the Middle East region. He also works with Deezer as the Artist Marketing Manager for Levant and Egypt, a role which allows him to promote artists from all over the region. To find out more about this work, you can visit his website here: http://www.anthonysemaan.net

Everyone and everything has been impacted by the Beirut port blast and multiform crises in Lebanon, including the music industry and scene. Concerts are almost non-existent everywhere in the world, but in Lebanon, the blast and economic crisis have made it incredibly hard for artists trying to make a living and for promoters and venues who were dependent entirely on live engagements. What we once knew as normality just a couple of years ago seems like a century ago. With this perspective, I do not think the country will be considered the cultural hub it was once perceived to be for quite some time. The deterring situation is still ongoing, so even though efforts are being made, we have to assume that it can always get worse.

There is a new reality and we have to accept it, but there is no right or wrong way to face all these crises and the new challenges that lie ahead of the Lebanese, especially artists. Some artists will choose to wait until things return to "normal" before getting active again. Others will adjust to the reality of trying new things that are currently working elsewhere around the world. Whatever they decide to do, it's up to us, social platforms and those who work in the industry, to show them support and to be there for them if needed. For artists, it is indeed platforms that allow them to work and earn money to do so. When the pandemic started, free online concerts were buzzing and it was rightfully a good thing to do. Under Beirut Jam Sessions, we did over 160 of them and it went pretty well, but soon enough, it was obvious that artists needed a way to make money. Any type of initiative that allows artists to use their creative talents and earn money is a necessity at this point. Funding and support programs are also great, not necessarily sustainable, but still important nevertheless.

Lebanese artists, and particularly emerging and marginalized musicians and performers, have more power than they imagine. What we are going through is not easy for anyone, but it will not last forever. We all have to adapt and artists have the power to do that better than anyone else!

RAMA'S WHISPER - ARTHAUS

VLADIMIR KURUMILIAN - MIM

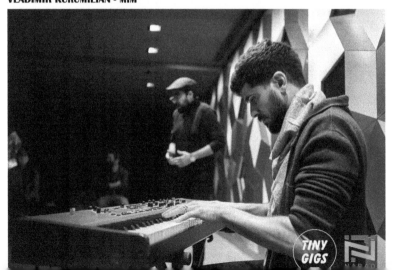

GHENWA NEMNOM - UNION MARKS

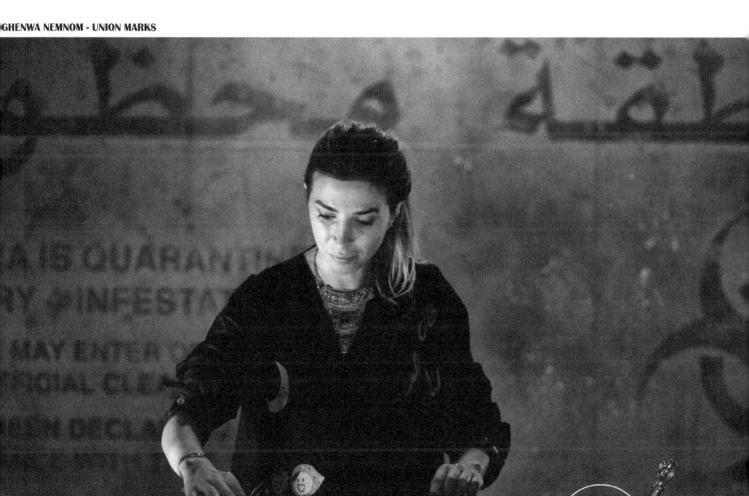

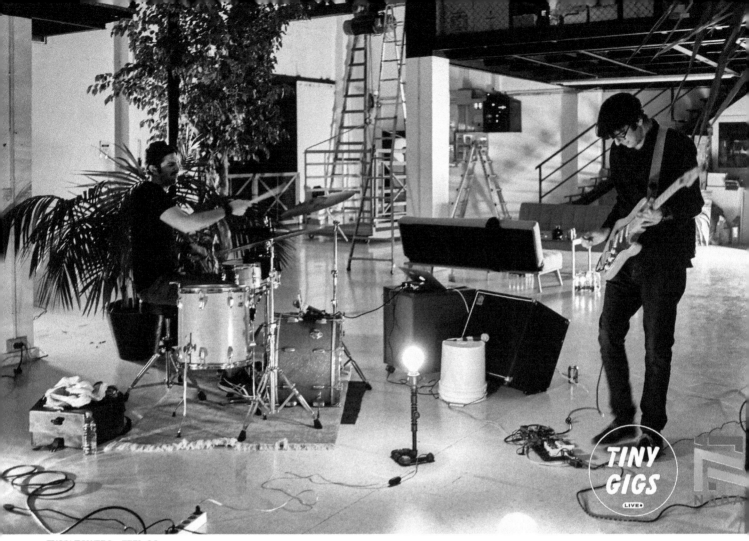

TWYN TOWERS - FEEL 22

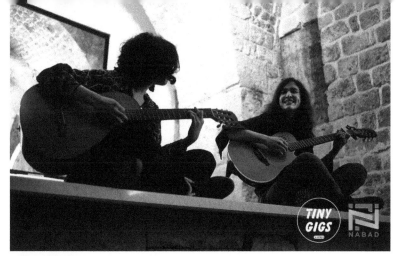

FRIDA - ARTHAUS

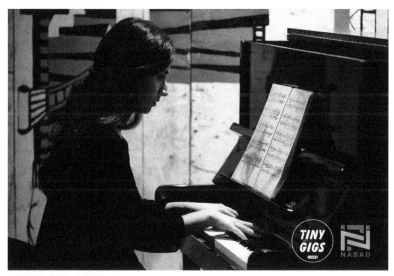

ANDREA AZZI - ARTHAUS

*Watch TINY GIGS excerpts of concerts on Beirut Jam Sessions (BJS) YouTube Channel: https://www.youtube.com/user/beirutjamsessions. Organized by BJS in December 2020 and January 2021 with the support of Nabad.

ROULA SALIBI

Come into Heaven, my Heaven

After a decade spent in the business world, Roula Salibi decided the time had come to embrace the true calling of her heart: the calling of art. She dedicated the next years of her life to learning all she could, including taking a series of intensive courses at ESMOD Beirut and imbuing herself in every aspect of the art world. While the materials Salibi uses in her work are conventional, accessible, and simple, the results are anything but. Geometric forms, which are a constant thread throughout her work, combine with the earthy, unfinished feel of rough gemstones. There is depth and tactile beauty in her silverwork, with each finished piece exhibiting its own distinctive personality. After exhibiting in Paris, Milan, London, New York and Dubai, Roula Salibi's pieces have extended into the Europe and Middle East market. Online platforms have also expanded her work worldwide.

You can follow Roula Salibi's art or learn more @iamminimalistlb on Facebook, or @I_am_minimalist_lb on Instagram.

My childhood was absolutely extraordinary. I grew up in a heavenly place, in Lebanon. It was not just any heaven, it was my heaven...

Running through the wild with my friends, every day...

Waking up to the smell of flowers, a gift my dad would bring my mother, every day...

A warm, big home, yet not too big to be full of love, laughter, creativity, and chaos, every day...

The mesmerizing smell of my mother's baking...

Her impeccable taste...

Glimpses of her secret recipes laid out on the kitchen table...

Infinite patterns on ancient textiles she magically transformed into clothes for my little body...

My childhood home, where I witnessed my parents' sweet love, for each other and for my four siblings...

Blasts from my distant past: my first date, my first kiss, my first breakup, and the many that followed, my sister's wedding day... All in that magical house, perched on the side of the mountain in the middle of nowhere...

Those blissful days and nights spent on that terrace with an astonishing view that embraced all of Beirut, reading, studying, or at least pretending to, tanning, and quietly hanging with my father in that amazing small garden he used to tend to, every day....

Memories flowing like a string of beads, some louder than others... In times of war, neighbors would huddle around the candle and gather around my father, the great storyteller. He enchanted them with his tales, the Thousand and One Nights kind! Despite the unraveling darkness outside, fear had no place inside...

I miss that home, every day. I miss my parents, every single minute of every single day...

I wonder sometimes if there could ever be a way back to that heaven?

My collections are my way of bringing back to life that long-lost place of wonder, and to explore a central theme of the natural world: each piece is an earthy, tactile beauty, each one unique and each one a representation of my world.

With every piece of jewelry that I create, I share with you a small part of my heaven. I hope that those who wear these pieces will also have a glimpse of what their heaven was like,

and in doing so, help me find the way back to mine...

Construct | Deconstruct | I Am Minimalist Collection | Our earth is resilient, and we are powerful. From the decay, we can reconstruct a stronger, healthier, sustainable earth. From the rubble we can construct a new earth, to our vision, and for all our futures.

CONSTRUCT_DECONSTRUCT

Drift | I Am Minimalist Collection | "In a dérivé, one or more persons during a certain period drop their relations, their work and leisure activities, and all their other usual motives for movement and action, and let themselves be drawn by the attractions of the terrain and the encounters they find there" - Guy Debord, Theory of the Dérivé | 1958.
The translation of dérivé is DRIFT.

DRIFT

EARTH

New Earth | I Am Minimalist Collection | Everywhere we look, beauty exists. How that beauty speaks to us, how we interpret it, and how we embrace it, lie at the heart of New Earth Collection. This collection delivers pieces of earthy, tactile beauty, each one unique, and each one a representation of our world.

Pastel Morning: One of Beirut's vernacular buildings at the end of Bliss Street. Painted in pastel pink, a color embodying an era that resonates with peace and the good old days.

ROULA-MARIA DIB

Meditations on an Olive

Roula-Maria Dib (PhD, Leeds) is an assistant professor of English at the American University in Dubai, and editor-in-chief of Indelible, the university's literary journal. A creative writer and scholar in the fields of literature and Jungian psychology, her poems, essays, and articles have appeared in several journals. She has authored *Jungian Metaphor in Modernist Literature* (Routledge, 2020) and a poetry collection, *Simply Being* (Chiron Press, 2021). The themes that pervade her poetry usually revolve around different aspects of human nature, ekphrasis, surrealism, and mythology.

We have all been pressed, coldly—
just like you,
only to embalm wounds with the oil from within
and anoint rites of passage.
We have survived deluges, after which our existence
became a fine sign of life, carried by the unclipped beak
of the dove
of hope.

Where there's an olive, there's a Gesthemane,
an impending scene of crucifixion and resurrection,
the clutches of betrayal and clinches of friendship.
Where there's an olive, there's the cycle of life,
tear-dropping, from the unbowing, leaf-laden boughs
that remain
tall, but humble.

Observing 1: A couple enjoying a visit to the Sursock Museum in Beirut during *La Nuit des Musées*, an event that occurs once a year, where people get to visit some of the most prominent museums in Lebanon, free of charge and for one day only.

Entropy

I am a million years older and younger than this moment.
What if I told you that as you orbit the center of this onyx void,
you will hear whispers and see
that I am the blade of your compass and the curve of your undrawn circles?
I am Pythagorus, still searching for the right angle.
I am Porphyry Malchus, trying out logic.
I am a mariner gone sailing, chasing after dreams,
and I see the sun to my right and declare the earth as spherical.

I was someone fed hemlock like Socrates,
arrested like Galileo,
but like Adonai, always returned.
What if I told you that Astarte and Adonis never died,
that Europa was a Phoenician princess,
made monarch in a strange, new island—a queen not without honor, but in
her own country, and among her own kin, and in her own house?

I am a symphony by the temple of Jupiter,
under Cassiopeia,
one summer night in Heliopolis.

I am Thekla, challenging all odds, like
Marinos, a monk infiltrating a sacred space I was denied.
I am Barbara in the wheat fields, and they will strike.
But lightning will bolt back.
And I will not fall.

I am Zeno, finding cures in the Epicurean,
standing in the face of stony faith,

siding by Bacchus under the vine,
sipping on a concoction
of Anise,
Chamomile, and dried Almond shells,
sweetened with Fig, Prunes and Honey.

I am that Olive tree, the club of Hercules and Melkart, gift of Athena.
I am that Fig, swollen and ripe, proud of my ruby interior
and that oxymoron of a Mint leaf, bitter with the sweetness of my healing
scents,
that Basil charm potted in an old milk tin at my grandmother's front door,
and a stretched field of Lavender, drying, not dying, like an unbroken spirit.
I am all those radiating Geraniums and Citronellas,
repelling pests with my beauty,
waiting in patient glee for the return
of that little girl plucking my petals to decorate her fingertips.
I am all these flowers and more, chosen on the morning of Good Friday,
decorating the Epitaphios and joining the savior
in both thanatos and anastasis.

I am an unfinished evening sandwich.
A stone fallen from a church dome.
People minding their own business.
A scream through the eye of the fire.
A pulse under the rubble.
A murex-shaped heart, broken into thousands of tesserae,
forming my story into a mollusc-ous mosaic.

I
We
They
will not apologize for the selfishness
and psychopathy. You cannot entice us
into Stockholm syndrome.

I am free, my wings light up an ancient fire, and
I
We
They
shall rise again,
just like every god
who has trod this land.

Observing 2: A group of people appreciating the book from the exhibition *The Distance Is Always Other*, by photographers Noel Nasr and Chris Coekin. Taken at Art Lab in Gemmayze, Beirut on opening night in 2018.

PAMELA CHRABIE

We are lights in the tunnel

Dr. Pamela Chrabieh (Badine) is a scholar, university professor, visual artist, activist, writer and consultant. She holds a Higher Diploma in Fine Arts and Restoration of Icons (1999, ALBA, University of Balamand, Lebanon). She pursued her higher studies at the University of Montreal in Quebec, Canada: Minor in Religious Sciences (1999), MA in Theology, Religions and Cultures (2001), PhD in Theology-Sciences of Religions (2005), and held two postdoctoral positions (2005-2008). Dr. Chrabieh has more than 20 years of extensive multidisciplinary and international experience and expertise in university teaching (Lebanon, Canada, United Arab Emirates), academic research, visual arts, art direction, communication, content creation, writing, project management, training and conference/workshop/webinar organization. She is the author of numerous books, book chapters, academic papers and online articles. As a visual artist, she has exhibited her work in Canada, Lebanon, the United Arab Emirates and Italy. She has founded an online movement of writers and artists focused on gender issues in 2012, has been an active member of local/ international NGOs, and a member of executive committees and advisory/editorial boards of several organizations since 1995. In addition, she has received several awards and grants in Canada, Lebanon and the United Arab Emirates. Since 2017, Dr. Chrabieh has been the owner and director of Beirut-based SPNC Learning & Communication Expertise, and since 2020, Nabad's Program Manager (nabad.art).

Official Online Channels:
Website/blog: https://pamelachrabiehblog.com/
Facebook Page:
https://www.facebook.com/pchrabieh
Instagram Account:
https://www.instagram.com/pamelachrabieh/

I was born and raised in the 1970s-1980s war in Lebanon.

War disconnects lives, memories, and experiences by creating endless cycles of violence, murderous identities, and wounded memories.

I have come to believe that these memories are inevitably transmitted across generations in private and public spaces, and that socio-political conviviality and peace need both individual and national healing processes. Otherwise, the load of traumas that we carry will prevail, fueled by the continuous local and regional crises and state-sponsored amnesia.

Growing up in war left me with a thirst to discover the truth behind the endless years spent in shelters and displacement, the survival techniques I learned, such as the ways to avoid snipers and land mines, the suffering following the destruction of our houses and the horrific deaths of loved ones, the fascination with war games I used to play, and the hours spent with my parents in search of bread.

War has definitely marked my identity, world vision, and visual expression, and it has fueled my pursuit for connections between cultures and religions; the contemporary and the traditional; the physical and the psychological; the visible and the invisible; the past, present, and future; the logos (word) and the eikon (image); the natural and the spiritual... My pursuit for peace...

Contrary to war, peace is the art of connecting. It is a continuous process encompassing historical subjectivities and energies in interpenetrative modes; a process of interacting dynamics, fragmented and common truths, voices, paths, and pathos.

My art is a visualization of this peacebuilding process. It symbolizes life versus death, positive movement towards the manifestation of connections, and therefore, towards forgiveness, healing, and conviviality.

"Reconquering the Beirut Egg", Sketch on paper and digital art by Pamela Chrabieh, October 2019 Revolution.

Each artwork is a story of transformation, from a shattered and disconnected situation, event, emotion or experience, to a connected realm, and this is how I am able to go through the tunnel of our life in Lebanon, by believing in the endless possibilities of lighting it with our narratives, memories, thoughts and praxis as we all walk through it.

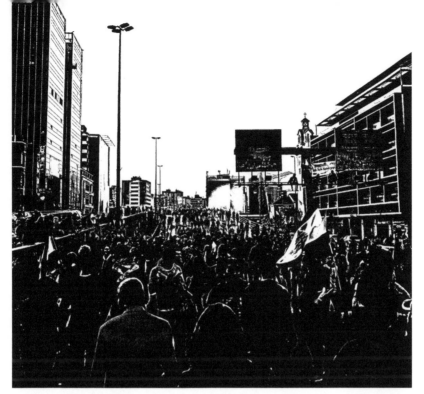

"We are all Lights in the Tunnel",

Sketch on paper and digital art by Pamela Chrabieh, October 2019 Revolution.

"United we Stand"
or
"Human Synergy",

Sketch on paper and digital art by Pamela Chrabieh, October 2019 Revolution.

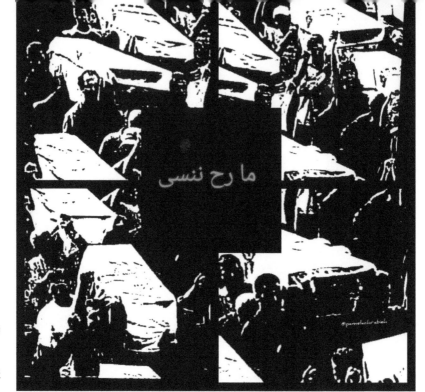

"Ma rah nenssa/We won't Forget",

Sketch on paper and digital art by Pamela Chrabieh, 2020.

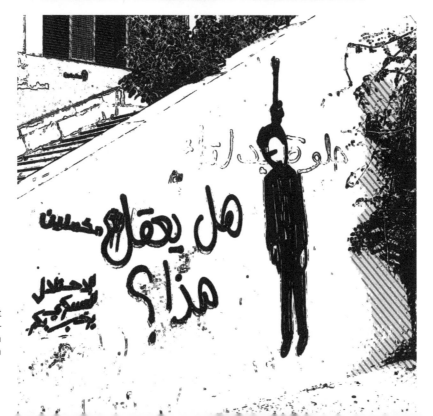

"Hal yuuqal hadha?/Is this possible-thinkable?",

Sketch on paper and digital art by Pamela Chrabieh, 2021—inspired by graffiti on a wall in the streets of Mar Mikhael in Beirut.

"Hayhat min al dhull/Oppression No More", Sketch on paper and digital art by Pamela Chrabieh, 2020.

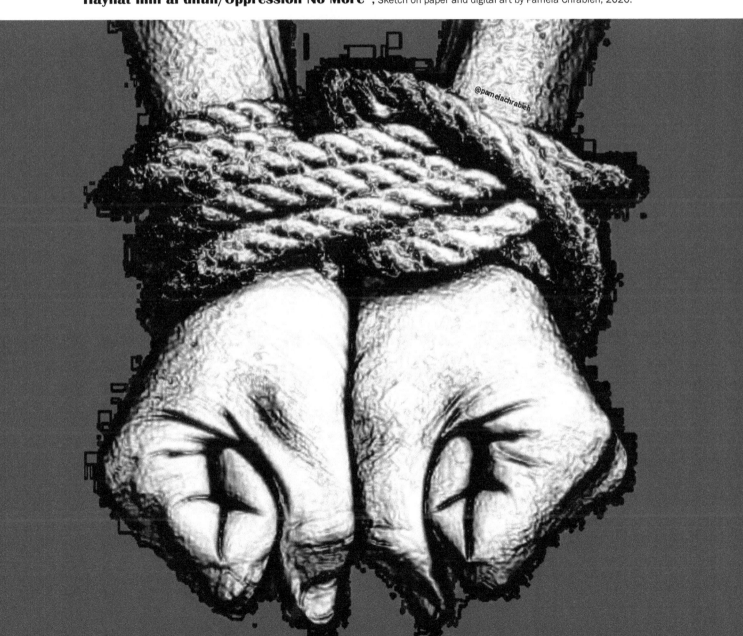

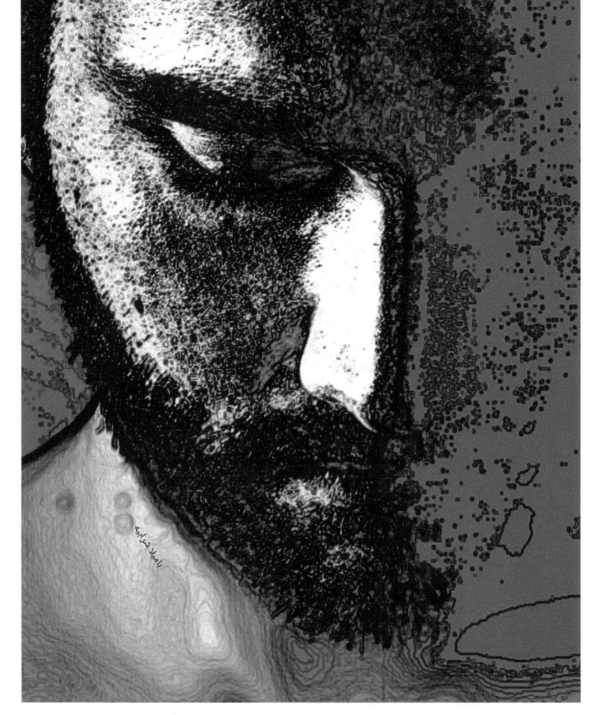

"Scattered", Sketch on paper and digital art by Pamela Chrabieh, 2020.

"Love is Always within Us",

Sketch on paper and digital art by Pamela Chrabieh, 2020 (replica of a poster found in the damaged area of Mar Mikhael following the Beirut port blasts).

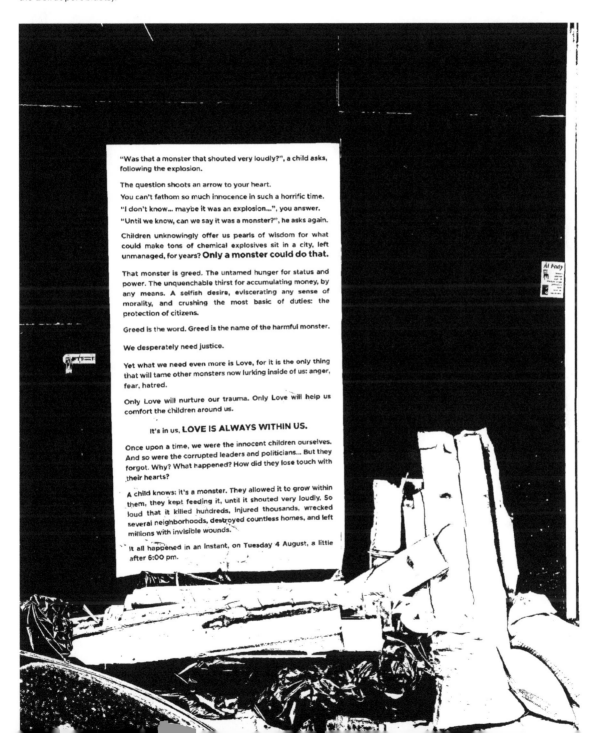

"Was that a monster that shouted very loudly?", a child asks, following the explosion.

The question shoots an arrow to your heart.
You can't fathom so much innocence in such a horrific time.
"I don't know... maybe it was an explosion...", you answer.
"Until we know, can we say it was a monster?", he asks again.

Children unknowingly offer us pearls of wisdom for what could make tons of chemical explosives sit in a city, left unmanaged, for years? **Only a monster could do that.**

That monster is greed. The untamed hunger for status and power. The unquenchable thirst for accumulating money, by any means. A selfish desire, eviscerating any sense of morality, and crushing the most basic of duties: the protection of citizens.

Greed is the word. Greed is the name of the harmful monster.

We desperately need justice.

Yet what we need even more is Love, for it is the only thing that will tame other monsters now lurking inside of us: anger, fear, hatred.

Only Love will nurture our trauma. Only Love will help us comfort the children around us.

It's in us, **LOVE IS ALWAYS WITHIN US.**

Once upon a time, we were the innocent children ourselves. And so were the corrupted leaders and politicians... But they forgot. Why? What happened? How did they lose touch with their hearts?

A child knows: it's a monster. They allowed it to grow within them, they kept feeding it, until it shouted very loudly. So loud that it killed hundreds, injured thousands, wrecked several neighborhoods, destroyed countless homes, and left millions with invisible wounds.

It all happened in an instant, on Tuesday 4 August, a little after 6:00 pm.

"Hurriye/Freedom", Sketch on paper and digital art by Pamela Chrabieh, 2021 –inspired by the Arthaus (Gemmayzeh) murals and graffitis.

The Scanners: A group of people appreciating the artworks of different local and international artists during the Beirut Art Fair 2018, a yearly collective exhibition that takes place in Beirut for a week. People, artists and gallerists alike enjoy art and beautiful design.

CONTRIBUTORS

REINE ABBAS

WADIH AL-ASMAR

PAMELA CHRABIEH

DORINE POTEL DARWICHE

FRANK DARWICHE

ROULA-MARIA DIB

ROULA AZAR DOUGLAS

KATIA AOUN HAGE

CLIFF MAKHOUL

LOULOU MALAEB

RABIH RACHED

MITRI RAHEB

NADA RAPHAEL

OMAR SABBAGH

ROULA SALIBI

ANTHONY SEMAAN

JOELLE SFEIR

LINDA TAMIM

NADIA WARDEH

FATEN YAACOUB

CARMEN YAHCHOUCHI

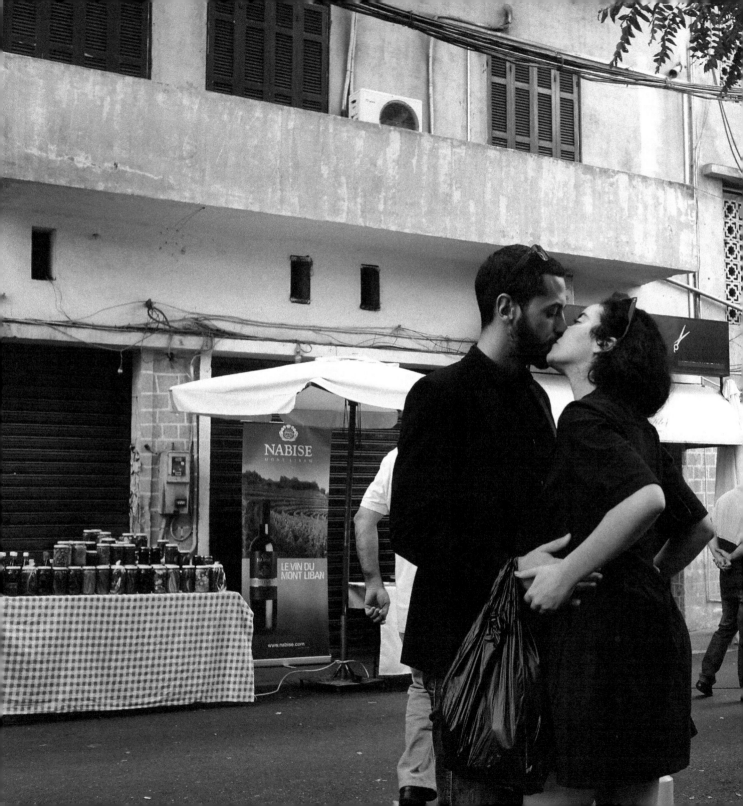

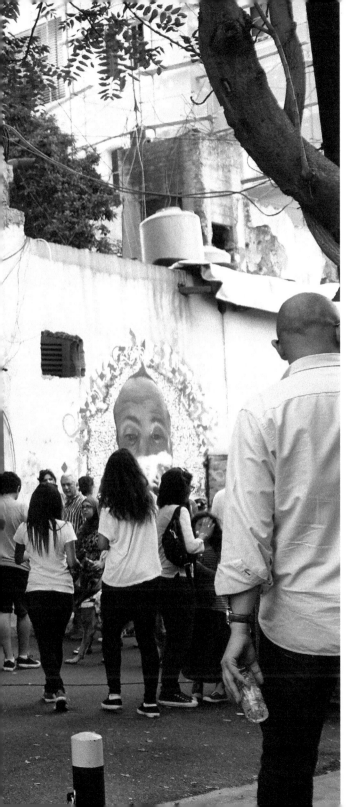

PHOTO CREDITS:

© **REINE ABBAS:** 99-100-101

© **DIANE AFTIMOS:** 202-203

© **ROULA AZAR DOUGLAS:** 180-181-183

© **KATIA AOUN HAGE:** 58-59

© **PAMELA CHRABIEH:** 160-161-162-163-164-165-169-218-219-220-221-222-223-224

© **FRANK DARWICHE:** 127

© **DORINE POTEL DARWICHE:** 174-175-176-177

© **CLIFF MAKHOUL:** 6-7-8-9-10-11-16-17-19-23-33-50-51-66-67-83-91-94-95-110-111-114-115-132-133-170-171-188-192-193-194-195-204-205-208-209-214-215-225-234

© **NADA RAPHAEL:** 137-138-139-140-141-142-143-144-145

© **ROULA SALIBI:** 201

© **DANIEL A SATER:** 199

© **CARMEN YAHCHOUCHI:** 118-119

Kiss of 2020: A candid shot of what seems to be a couple kissing during an event titled *Ashrafieh* 2020 back in 2014. A scene that feels surrealistic seeing it in 2021.